MOSAIC

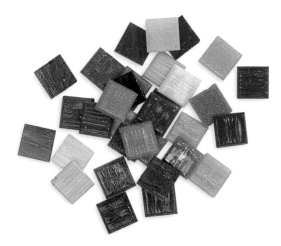

STYLISH & SIMPLE

MOSAIC

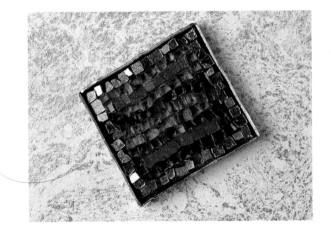

EMMA BIGGS & TESSA HUNKIN

AURUM PRESS

First published in 1998 by

Aurum Press Ltd

25 Bedford Avenue

London WC1B 3AT

Conceived and produced by Breslich & Foss Ltd

20 Wells Mews

London W1P 3FJ

Project editor: Janet Ravenscroft

Designer: Janet James

Photographer: Shona Wood

A catalogue record for this book is available from the British Library

ISBN 1 85410 556 6

Printed and bound in Hong Kong

Contents

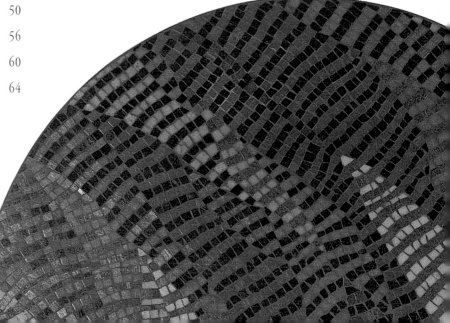

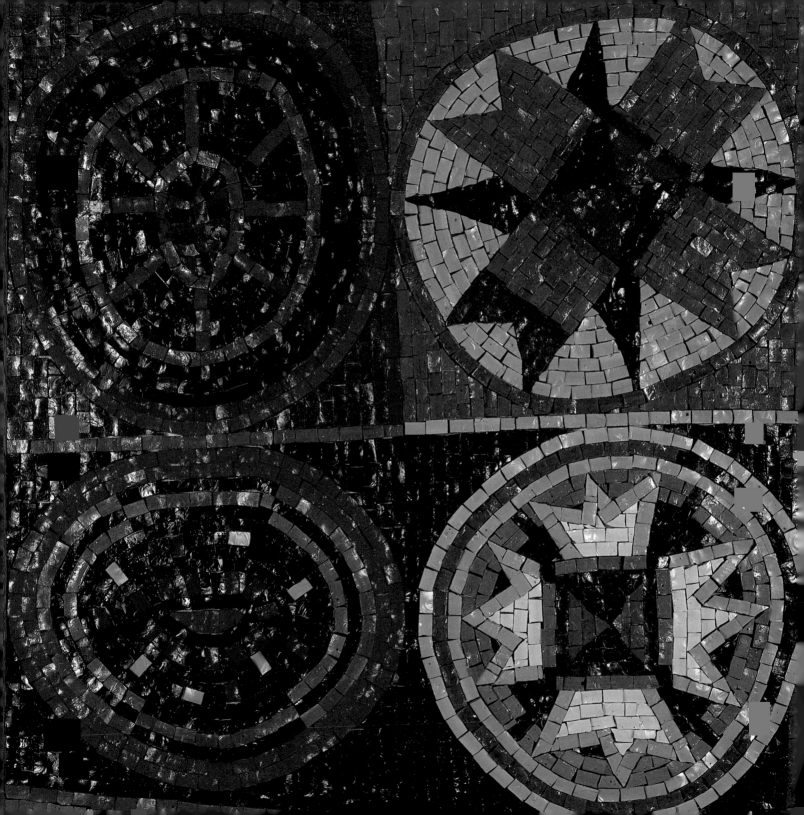

INTRODUCTION

Mosaic was first used by the Ancient Greeks, who made decorative pavements out of contrasting pebbles. The Romans developed the technique, using marble cubes and glass tiles or 'tesserae', and mosaic floors are found throughout their empire from Britain to North Africa.

In the Early Christian period, enamelled glass 'smalti' were used to create large mosaics on the walls and vaults of churches. The most important examples are to be found in Ravenna, north-east Italy, where a series of churches was decorated with mosaics of extraordinary power and magnificence in the fifth and sixth centuries AD.

During the Middle Ages, mosaic became a widespread decorative technique both in the West and in the Byzantine Empire. St Mark's church in Venice and the Santa Sophia mosque in Istanbul contain fine examples, illustrating the characteristically lavish use of gold as a background colour.

The use of mosaics declined after the Renaissance but they did continue to be made (particularly in Italy) throughout the sixteenth, seventeenth and eighteenth centuries. The nineteenth century saw a revival of interest in all kinds of decorative techniques, including mosaic. In particular, the European movements of Art Nouveau and the Vienna Secession used mosaic in new ways and in many different types of building including houses, railway stations and department stores.

This century, new mosaic materials, both glass and ceramic, have been created by industrial processes. They were designed to be used in large areas, and office blocks of the post-war era are often clad in acres of glass mosaic.

At the Mosaic Workshop, we are interested in using both traditional and modern materials and techniques. This book is aimed at providing a brief introduction to the huge variety of effects that can be achieved in mosaic.

CHOOSING A DESIGN

Designs and sources of inspiration can, of course, come from anywhere, but there are two main considerations. First, mosaic is inherently a fussy medium and it tends to be most effective in a relatively simple design. Second, the art of making something in mosaic will transform it completely from the original image. This can be a great advantage because, if you are copying something, you will end up with a new and original piece. But it can also be disappointing if you are not prepared for the different effect. There are templates for design ideas at the back of this book.

The small square mirror shown below is obviously a very simple design, requiring no cutting other than the quartering of the tiles. It relies for interest on the patterns that can be made with colour and uses the inherent property of mosaic – that it comes in small pieces – to maximum advantage.

The duck mirror (opposite) is a larger piece and, consequently, a little more elaborate, but it works along the same principles. Here a virtue is made of the hand-cut quarters, allowing their natural irregularity to give the piece a slightly wobbly and 'handmade' quality.

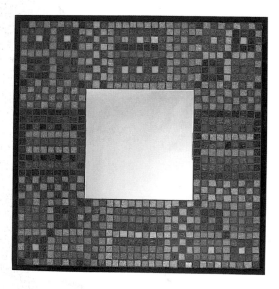

The circular ceramic mirror (below) is another piece where the design is generated by the properties of the material used. Here the pieces are cut down from larger tiles and can therefore be easily made into a range of different shapes. The colour contrast is very subtle and the interest comes from the pattern of the joints.

METHODS

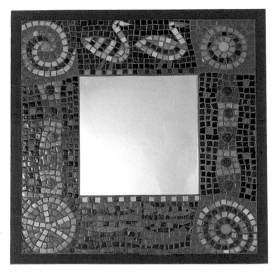

Direct method

Whatever material you are using, there are two distinct methods that may be employed. In the direct method, the pieces are stuck directly to the backing material, one by one. This technique is useful when the material used has a different appearance on the front and back faces. Examples of this are glazed ceramics and polished marble cubes. The direct method is also used if the pieces are of varying thickness and the finished work is going to have a 'relief' or slightly 3-D surface.

Indirect method

When the indirect method is used, the pieces are stuck upside-down to a piece of paper on which the design has been drawn in reverse. The finished piece is therefore 'paper-faced' and offered up to the adhesive either whole or in large sections, and the paper then soaked and peeled away. This method allows greater flexibility in making up the design because alterations can easily be made. It is also easier to see what you are doing because the drawing is not obliterated by a layer of adhesive. For large-scale works this technique is invaluable because the mosaic can be produced in the studio and carried to the site for assembly.

The indirect method can also be used to create a flat surface when using pieces of varying thicknesses if a thin layer of adhesive is applied to the back of the piece before fixing.

TESSERAE

Vitreous glass tiles

Tesserae is the name given to the glass and stone pieces used to make a mosaic. Vitreous glass tiles are 20 mm (³⁄₄ in) square and available in a wide range of colours. They can be purchased on paper-faced sheets of single colours that are approximately 30 cm (1 ft) square (225 tiles). Some suppliers sell them loose and in smaller quantities. When cutting the tiles for a design, you should allow about 20 per cent wastage.

Above: Vitreous glass tiles are available in sheets of 225 tiles.

Left: If you need a wide range of colours, buying a bag of loose tiles might be the cheapest option.

Below: Smalti come in muted colours as well as bright ones.

Smalti

This is the traditional enamelled glass material used by the Roman and Byzantine mosaicists that is still manufactured in Italy. It is made in large, irregular circles like omelettes and cut up into slightly uneven rectangles which are sold by weight. Each colour is sold in a minimum quantity of ¹⁄₂ kg (1 lb). Alternatively, you can buy bags of mixed colours that are made up of the off-cuts from the edges of the 'omelettes'.

Ceramic tiles

Ceramic tiles are available in either paper-faced sheets, like vitreous glass tiles, or on mesh-backed sheets. Each tile is 25 mm (1 in) square. Peeling tiles off mesh can be time-consuming, so if you need loose tiles, choose paper-faced ones. Most ceramic wall tiles can be cut down to use in mosaic, but you may wish to avoid those with a bevelled edge that may make the edge pieces look different from the others.

A range of ceramic tiles.

Marble

Most marble cubes are produced by cutting up polished marble tiles on a wet-saw. They are available in single colours on a webbed backing in sheets approximately 30 cm (1 ft) square. This backing is designed to be impossible to get off, so if you intend to use the cubes loose, it is important to buy them loose. Each cube has a polished face and a more muted, saw-cut face, either of which can be used. You can cut cubes in half yourself with tile nippers (see page 18) to produce a rough crystalline surface. A cube cut this way is known as 'riven'. Marble pebbles are also available.

When a marble cube is cut in half, its crystalline interior is revealed.

OTHER MATERIALS

Any material that naturally comes in small pieces can be used in mosaic, for example: shells, beach pebbles, metal nuts, beads, buttons, etc. Equally suitable is any material that can be cut or broken easily, such as coloured glass, mirror glass and crockery.

BASES

Boards

If you are making a mosaic to go outside you must use exterior grade plywood (also called Marine ply) or hardwood, and if the piece has a frame that should also be hardwood. For indoor locations you may use any kind of timber or ply, but MDF (medium density fibreboard) is particularly suitable because it is very stable and will not warp or move with atmospheric changes.

Very thin boards – 9 mm (³∕₈ in) – thick can be used as bases for mosaics of up to 40 cm (16 in) square. Before starting the mosaic, attach a batten to the back of the board to which hanging brackets can be screwed when you have finished.

Larger mosaics need thicker boards to ensure stiffness. For pieces over 1 metre (1 yard) square, it is a good idea to use a 12 mm (½ in) board with cross-bracing at the back to reduce the weight of the finished piece.

Walls

Base plaster should be primed with a preparatory primer. If the surface is painted remember that you will be relying on the bond between the paint and the wall, so check that this is sound. Sand-cement render is a good backing for mosaic and essential in wet areas and outdoors. Remember that you will probably be using a very thin bed of adhesive and any lumps or bumps in the background will be reflected in the finished surface.

Floors

Timber floors should be covered in 15 mm (¾ in) ply screwed down at 23 cm (9 in) intervals. Marine ply should be used in bathrooms and kitchens because it will stand up to damp conditions. A layer of sand and cement would form a suitable backing surface, but obviously the flatness of the surface is even more crucial on floors than on walls.

A selection of projects from the book:

Top left: the Splashback project from page 34.

Top right: the Garden Panel from page 60.

Bottom left: a close up of the zebra from the Animal Frieze on page 43.

Bottom right: the Smalti Dish from page 80.

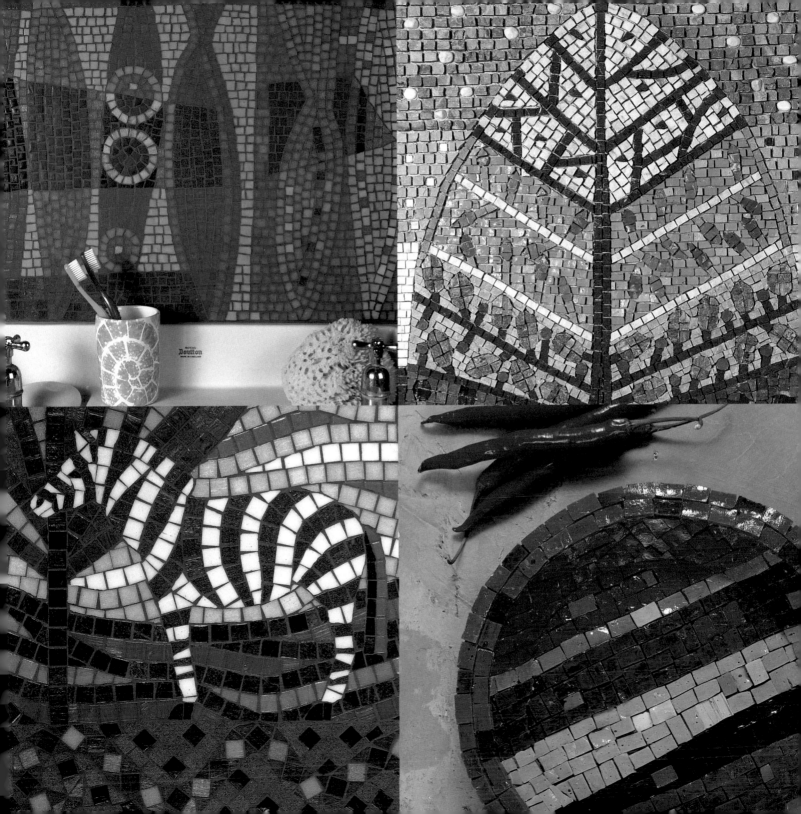

CUTTING TOOLS AND ADHESIVES

Tile nippers

These are an essential tool for cutting glass, ceramic, marble and smalti. To cut thin materials, such as vitreous glass, the nippers should be placed at the edge of the tile. For thicker materials, such as marble and smalti, place them across the piece in the line of the desired cut. Accurate cutting takes some practice, but remember that pieces that come out the wrong shape are bound to fit beautifully somewhere else.

Tile cutter

This tool has a scoring wheel to run along the line of the cut and a snapper to hold over the score-line to encourage the tile to break along the line. Available from all tile shops, tile cutters are useful for cutting up tiles over 25 mm (1 in) square.

Glass cutter

Ordinary glass cutters with a scoring wheel are available from hardware shops and are necessary for cutting stained glass. A score-line can also help you cut silver and gold mosaic accurately.

IMPORTANT

Whenever you are cutting tiles, wear safety goggles. It is also advisable to wear a mask when working with mosaic. Sweep up any dust and shards of glass regularly.

ADHESIVES

The choice of adhesive depends on the material being used, the base to which it is stuck, and whether the mosaic is for indoor or outdoor use.

Water-soluble PVA (polyvinyl acetate)

This is not a fixing adhesive, but is used in the indirect method for the interim stage of sticking the pieces to paper. It should be diluted 50/50 with water before being brushed onto the paper. After soaking, the paper is peeled off the mosaic pieces.

Non-water soluble PVA and EVA (ethylene acetate)

These are used in the direct method and are suitable for fixing flat-backed materials such as ceramic tiles to timber or MDF bases. PVA is used for dry areas while EVA is used for wet areas, but we would not recommend using either for external locations.

Cement-based adhesives

Interior rapid-setting cements are useful for fixing pieces made by the indirect method to boards and directly to walls. Exterior slow-setting adhesives are available for pieces made indirectly and for direct work. We also recommend using slow-setting adhesive for interior mosaics made using the direct method, as it gives a longer working time. When sticking to boards, both interior and exterior adhesives should be mixed with a latex additive such as Admix Ardion 90, which can be purchased from tile suppliers. It is a liquid that is diluted 50/50 with water and used to mix up powdered, cement-based adhesives. Latex improves the flexibility and adhesion of the adhesive and we recommend its use in any circumstance where the mosaic may be subject to special strains such as handling, vibration, variations in temperature, etc. It is also recommended for use in wet areas.

Silicone sealant

This is available from hardware shops in cartridges for use with a mastic gun. Silicone sealant is recommended for gluing glass, whether to stick mirrors to boards or glass to glass. Clear silicones should be used if a transparent effect is required.

Sand and cement

A mixture of sand and cement is the traditional material for fixing mosaic. It is still widely used for fixing floors where a level surface is necessary. The sand and cement is laid in a bed up to 30 mm (1¼ in) thick and the mosaic beaten down into it, thus taking up any minor irregularities in either the floor or the mosaic.

GROUT

Grout is used to fill in the gaps between the mosaic pieces. It is essential in areas that need to be kept clean, such as kitchens and bathrooms, because it gives the mosaic a uniform surface that can be washed down. Any kind of tiling grout can be used, although manufacturers often recommend a finer grout for narrow joints. Grout is available ready mixed and in powder form to mix with water.

Small Round Mirror

When making a mosaic mirror frame, it is important that the area to be tiled is wide enough to make something interesting, but not so wide that it makes the mirror look tiny in the middle. As a general rule, the diameter of the mirror should be larger than the width of the surrounding area.

Limit materials to a few basic colour groupings. In this project there are three: the dark colours (black, green, and blue), the yellows and golds (the broken china, gold tiles, and glass pieces), and white (white tiles, frame and grout).

We have used a framed board, the raised edge of which helps to protect the outer pieces of mosaic. If you can't find one, use a circle of MDF and paint the edges white to match the grout.

In this first project, you will learn how to score and snap ceramic tiles, and shape vitreous glass tiles into rounds with nippers. This mirror, like those shown on pages 12-13, uses the direct method, which means that the mosaic tesserae are glued directly onto the surface, right side up.

MATERIALS YOU WILL NEED

Pencil
Ruler
Mirror frame or circle of
9 mm (³/8 in) MDF
Tape
Mirror
Ceramic tiles
Tile-cutter
Nippers
Gold tiles
Plate
Hammer
Cloth
Non-water-soluble PVA glue
Silicone sealant
White tiling grout
Rubber gloves
Sponge
Lint-free cloth

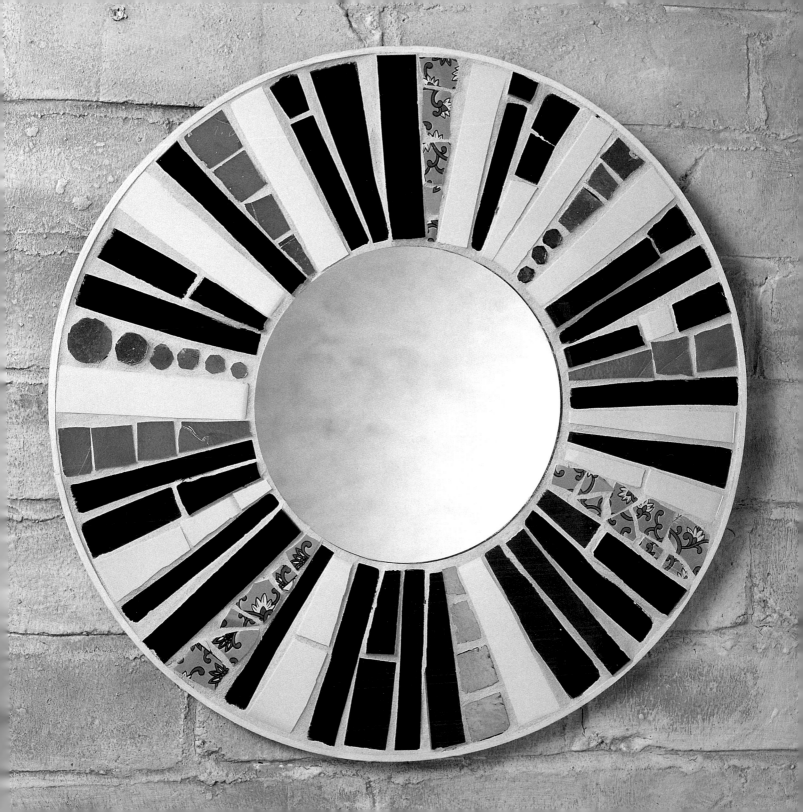

1 Draw radiating lines from the centre of the frame to its edge to act as a guide for positioning the tiles. Tape the mirror, right side down, to the middle of the frame.

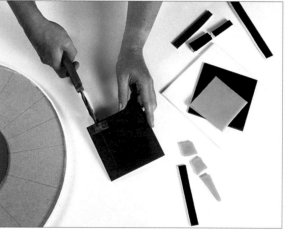

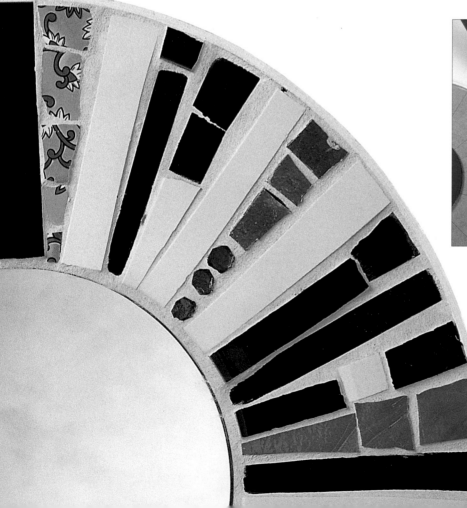

2 Choose a selection of tiles. Using a tile-cutter, score a line on the tiles to mark off a narrow strip. To make the strips fit around the circle, they should taper slightly at one end. Place the tool over the score mark and snap.

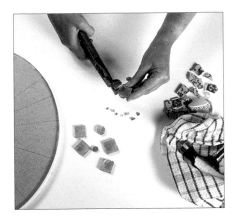

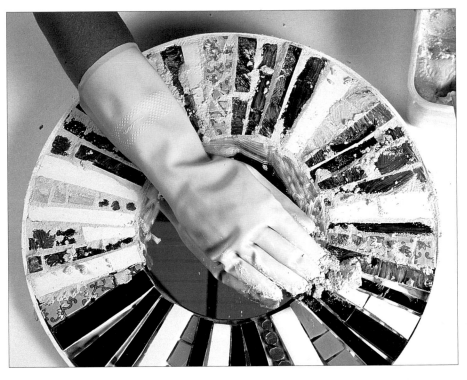

3 Shape the gold tiles into rounds by gradually 'nibbling' away the corners with the nippers. Next, smash an old plate with a hammer, first covering the plate with a cloth to prevent shards flying everywhere. (Mugs have round sides, and are not recommended for this kind of project.)

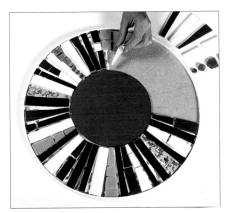

4 Fix the mosaic pieces to the board using a thick layer of PVA glue, cutting more tiles to fit the frame as you need them. Try to keep a consistent gap between the different elements.

5 Carefully lift the mirror from the frame and discard the tape. Apply a generous layer of silicone to the frame, and fix the mirror in place. Mix up the grout and spread it over the surface of the tiles, working it up to the edge of the mirror. Use your gloved hands to work the grout between the cracks. Rub off the excess with your fingers as you go.

6 Clean the grout off immediately with a decorator's sponge soaked in clean water and wrung out until just damp. Make a single wipe with each side of the sponge then rinse. Going over the tiles with a dirty sponge smears them with grout. Leave to dry for one hour, and polish with a clean, dry cloth.

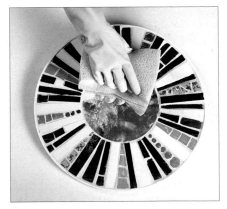

In the Optical Table, *the different intensities of the bright red and oranges is clearly shown. When the bright tiles are put next to each other they merge together, but when separated by a contrasting grid, their qualities become clear. By arranging them according to their intensity, the illusion of a bright light source under the grid is created.*

COLOUR AND PATTERN

One of the great attractions of working in mosaic is the wide range of colours available in both vitreous glass and smalti. Selecting a palette is an essential stage in designing a mosaic. It is tempting to select individual colours that are appealing in themselves, but the success of the design will depend on the relationship of the colours to each other. All colours have three distinct qualities:

HUE	**TONE**	**INTENSITY**
whether they are green, blue or red, etc.	*whether they are dark, light or in between*	*whether they are pure and bright or muted*

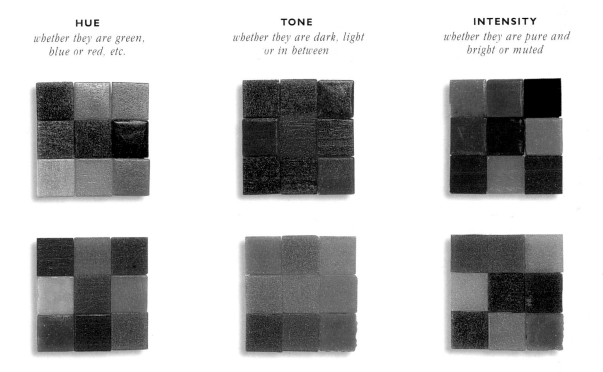

Colours that have any one of these qualities in common will immediately have a close relationship. For instance, colours of the same tone will always be harmonious together, and very bright colours will achieve a kind of balance. Equally, contrast can be achieved by juxtaposing colours with opposite qualities in any one category. Light colours will stand out against dark colours, and bright colours against muted ones.

The *Library Shower* mosaic demonstrates the effect of using a limited range of hue. The piece is essentially made up of shades of grey and green, but reds and yellows are used to provide highlights in intensity. The tonal contrasts of alternating dark and pale backgrounds give the design definition. The same coloured bowls and jugs are given a different character by their contrasting backgrounds. The dark grout unites the dark areas but breaks up the pale areas, particularly the monochrome frieze at the top, which is enlivened by the grout line patterns.

In *Progress*, dark and light tones are used in the background and on the figure itself to create an illusion of three-dimensionality and form. The imagined source of light is in opposite directions on the figure and the background, allowing greater contrast and definition between the two. We have used a mid-tone grey grout that breaks up the dark and light areas,

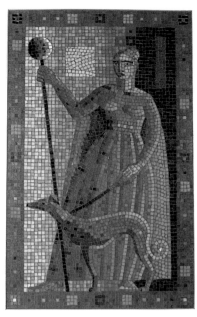

Progress

giving them the balance necessary for the composition. This is a device often used in portraiture, both in oil paintings and studio photographs.

The *Smalti Head* shows how intensity can be used to powerful effect. Smalti is an inherently intense material, but some of the colours are still stronger than others. The brilliant yellows of the hair are used to balance the red of the mouth. The form of the face is described using different tones, but these have been selected from a variety of blue, green and grey hues to give the piece more interest and to reflect the complexity of the colour of human skin.

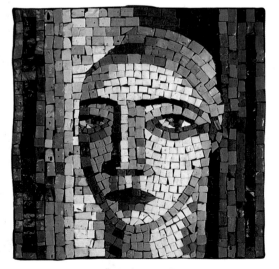

Smalti Head

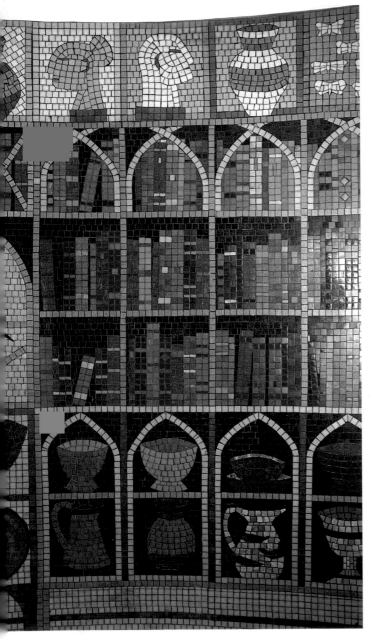

Library Shower

GROUT CONTRASTS

When working with vitreous glass, it is important to take into account the colour of the grout. It is possible to use coloured grout, which has the effect of making the joints invisible, but for most mosaics the pattern of the joints is an essential part of the piece. A grout of neutral hue (white, grey or black) won't clash with the hues of the tiles. The difficulty comes in deciding how dark or light the grout should be, and this will vary according to the piece. Contrasting grout makes the joints very noticeable and has the effect of breaking up areas of colour, while grout of the same tone will unify the colour by reducing the prominence of the joints. Another consideration is that dark grout brings out the intensity of the colours far more than white or grey.

The effects of black and white grout.

PATTERN

Because mosaic is made up of repeating elements it is an ideal medium for the creation of patterns. Both the selection of colours and the way in which they are laid can be used to make these. A single colour laid in a grid pattern has a very different effect when laid 'offset', as a brick pattern. The simplest patterns are random mixes of colours, such as the three examples shown here. The pattern is not structured but neither is it completely according to chance. The bright 'accents' must be distributed with care so that they are relatively even and not all clumped together in one corner.

Pattern is commonly thought of as a repeating element as in the *Leaf Border* and traditional Roman borders. Before embarking on miles of repeating border it is worth remembering that making the same thing over and over again loses its charm after a while unless, like the Romans, you have slaves! Designing repeats is also not always as easy as it looks.

Leaf Border

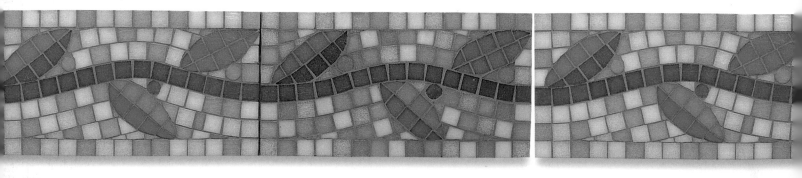

The *Camouflage Table* is a composition of different striped elements. It shows how pattern can be used in the same way as texture or colour to define areas, and how boundaries between different patterned areas can be used to dynamic effect.

In these panels that we designed for a restaurant (below), areas of pattern are used as background to the bowls and dishes. The woven design suggests tablecloths and place mats, and gives the panels a lively, flickering quality.

Camouflage Table

Restaurant Panels

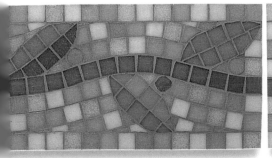

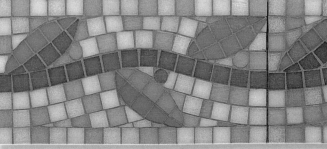

Horse Tile

This project uses the indirect method, a technique widely used by professional mosaicists as it allows large projects to be made up in the workshop and transported to site for final assembly. It is also a very useful way of working on small projects, because it allows you to take your time over a piece without fear of the adhesive drying out before you have made your design decisions. You may find that you want to make small alterations to improve the overall balance. An advantage of the indirect method is that the mosaic tiles can easily be peeled off and replaced.

A wide range of colours are used in this piece, but they are mostly green and blue hues from the less intense range. We have used a lot of contrast in tone to create the dark areas under the trees and horse. Where the shapes are not clearly defined by contrast, intense colours have been introduced, as in the red on the tail and the yellow and orange in the mane and nose.

A decorated tile like this one can be used as a pot stand if you glue felt to the base to prevent it scratching the surface of your table. Alternatively, tiles can be fixed to a wall with tiling adhesive or used as decorative panels in a garden or as a splashback behind a wash basin.

MATERIALS YOU WILL NEED

Scissors
Brown paper
Ceramic floor tile
Charcoal pencil
Nippers
Vitreous glass tiles
Paintbrush
Water-soluble PVA glue
diluted 50/50 with water
Black grout
Rubber gloves
Sponge
Cement-based adhesive
Notched trowel
Squeegee (a tool with
a rubber blade)

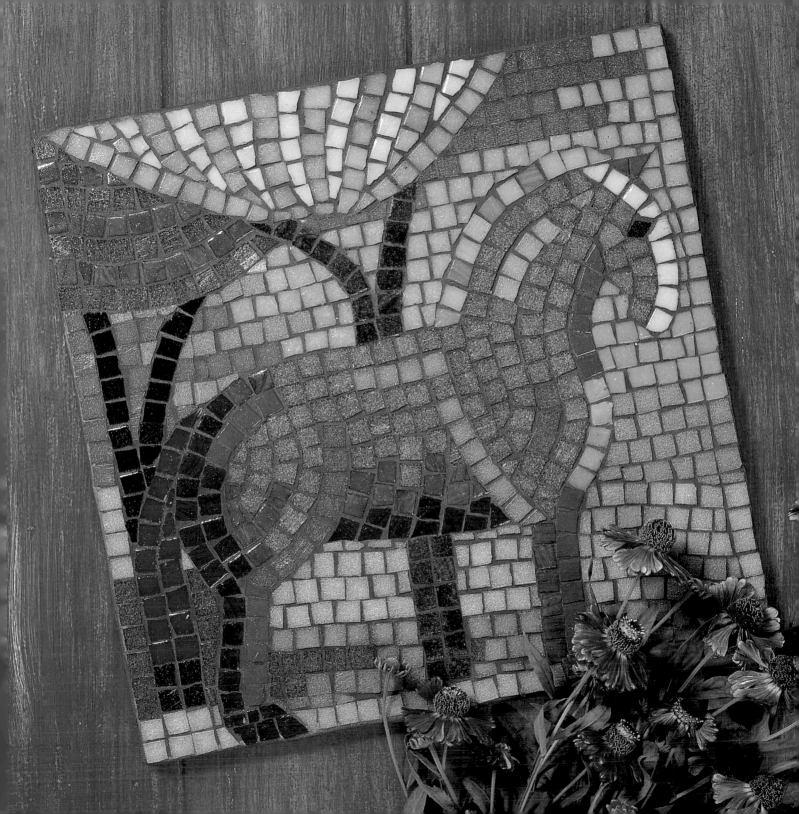

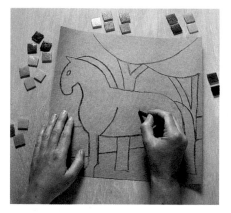

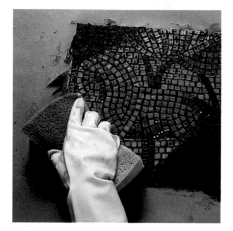

1 Cut a piece of brown paper to fit the floor tile you intend to mosaic. Sketch out your design on the piece of paper with a charcoal pencil. Charcoal is good to use because it is easy to rub out and correct. This is particularly useful on large pieces. Choose a palette of colours.

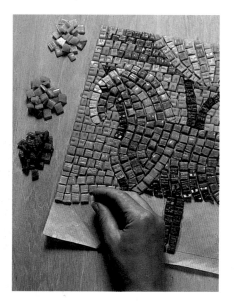

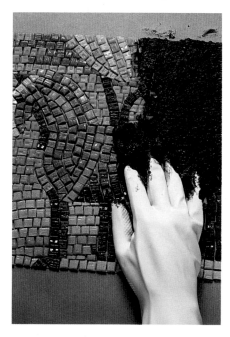

4 Clean the back of the mosaic with a squeezed-out sponge. Make a single wipe with each side of the sponge then rinse it out and begin again.

2 Nip the tiles into quarters by cutting them in half, then in half again. Brush glue on the paper and stick the tiles to it, flat side down, leaving a consistent gap between them. Work in small sections, doing the main figures first and filling in the background last. Nip the tiles into shapes that fit the design. Leave to dry for one hour.

3 If you care about your work surface, cover it now with paper. Pre-grout the mosaic using your gloved hand to work the grout between the tiles. Filling the gaps with grout prevents adhesive squeezing up between the joints and helps the adhesive to bond.

5 Spread the cement-based adhesive over the smooth side of the floor tile, using a notched trowel. This tool ensures that an even thickness of adhesive is applied to the surface of the tile. Keeping the mosaic design flat, lay it on the tile and press down.

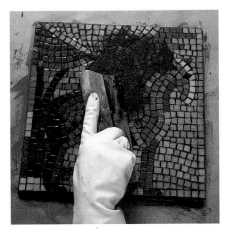

7 Mix up a fresh batch of grout and spread it over the mosaic with a squeegee. Don't forget the edges of the tile. Work the grout in well, then clean the surface with a squeezed-out sponge and leave to dry for at least an hour.

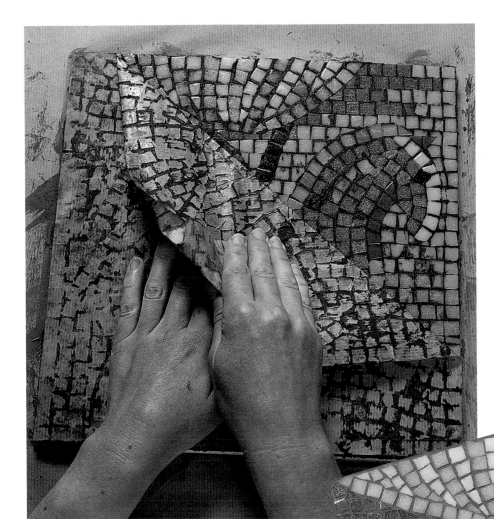

6 Dampen the backing paper with a sponge, keeping the paper wet for about ten minutes. Start to peel the paper from a top corner of the mosaic, keeping one hand flat on the tile. Peel from the other corners in turn, working towards the centre. If any of the tiles come loose, glue them back. Spread adhesive around the edge to protect it. Use a sponge to clean off the grout from the face of the tile and smooth out the grout left in the joints.

Splashback

This splashback shows how colour can be used to create a sense of depth and transparency. Simple transitions of colour create the illusion of translucent forms suspended in front of the fish shapes. The colours within the rectangles are transformed in different ways, either becoming darker or brighter, but maintaining a strong relationship that allows the background and foreground shapes to read with equal clarity.

The colours used in this piece are selected from a range of blues, greens and purple-greys, with accents of yellow. In a colour composition of this kind, it is a good idea to produce a colour drawing first. That way you can work out how to make the colours balance. For example, the turquoise green background on the left side is balanced by the lime-green shapes on the right.

This piece was made using the indirect method and worked in the same way as the Horse Tile (see pages 30–33). Draw a simple outline on tracing paper, turn it over (because the mosaic is produced using the indirect method), and enlarge it on a photocopier. Trace the enlarged design onto brown paper using a lightbox if you have one, or by holding the two sheets of paper against a bright window. Alternatively, the outline can be enlarged directly onto the brown paper by drawing a grid with the same number of squares on both the original and the brown paper, and copying the design freehand, square by square.

Glue the mosaic to a sheet of Marine ply using an appropriate adhesive combined with a latex additive, and attach it to the wall using mirror plates, or fix it directly to a prepared wall.

MATERIALS YOU WILL NEED

Colour sketch (optional)
Tracing paper
Pencil
Brown paper
Vitreous glass tiles
Nippers
Paintbrush
Water-soluble PVA glue
diluted 50/50 with water
Black grout
Rubber gloves
Sponge
Cement-based adhesive
Latex additive
Notched trowel
9 mm (³/₈ in) Marine ply

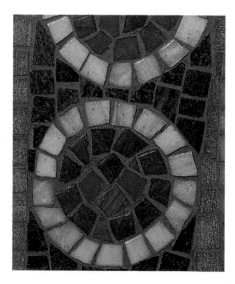

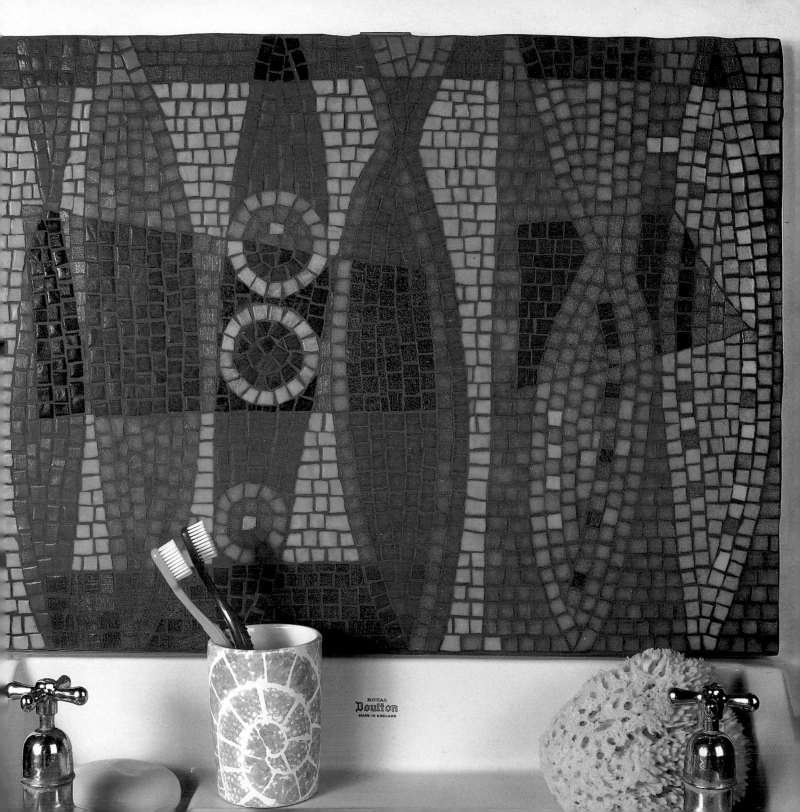

ROYAL
Doulton
MADE IN ENGLAND

Tiles on Mesh

These tiles are ideal for breaking up expanses of plain colour. Plan how many decorative tiles you need before you begin, and choose colours that will complement the plain ones. Because the decorative tiles are small, keep the design simple. Remember that the colour of the grout will also be part of the finished effect. Here we have used a brilliant white.

The technique of sticking to mesh enables you to see the finished effect while you are working. If you need to make alterations, simply remove the tiles before the adhesive has dried. The silicone-backed paper used in Step 3 will prevent the mesh sticking to your work surface.

MATERIALS YOU WILL NEED

Scissors
Brown paper
Black marker pen
Tapestry mesh
Silicone-backed paper
Nippers
Vitreous glass tiles
Non-water-soluble PVA
White tiling adhesive
Notched trowel
Rubber gloves
Squeegee
White grout
Sponge
Lint-free cloth

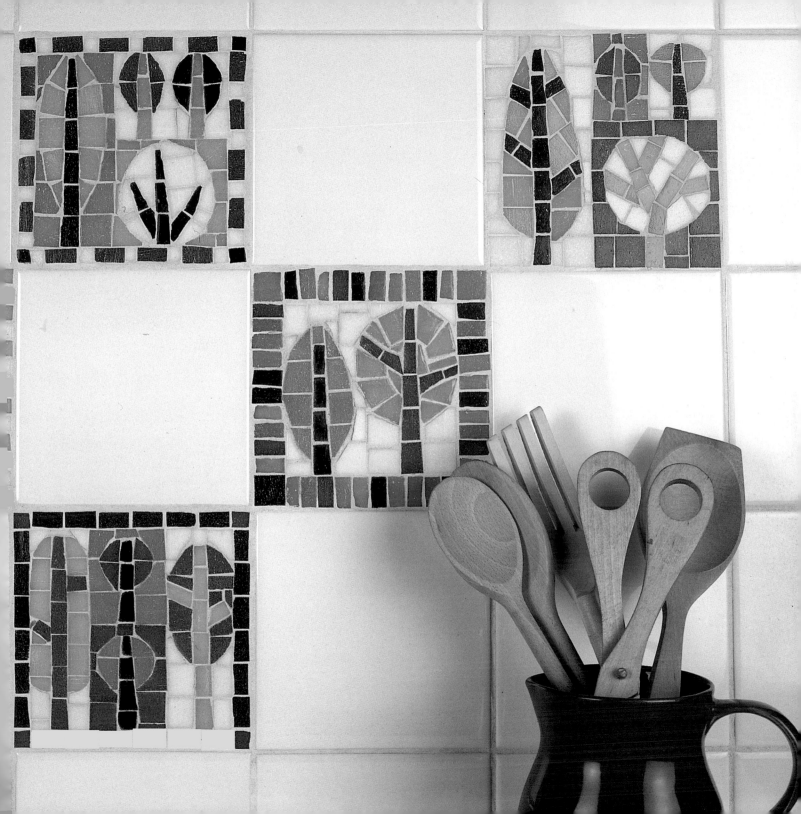

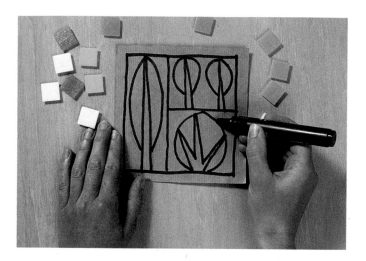

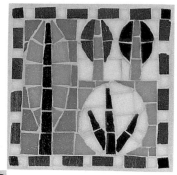

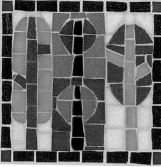

1 Cut a piece of brown paper as large as the plain tiles you intend to fix to the wall. Draw the pattern with a thick black marker pen that will be visible through the mesh. Choose a palette of colours.

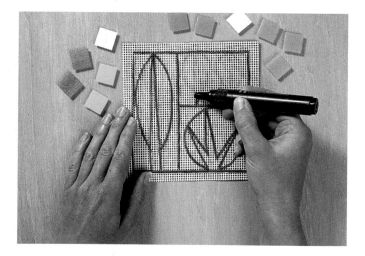

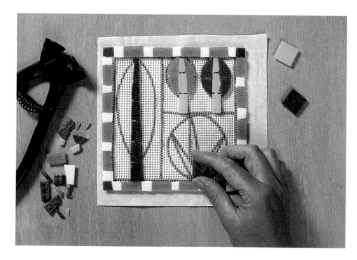

2 Cut a square of tapestry mesh the same size as the piece of paper. Lay it over the paper, and trace the design onto the mesh.

3 Place the mesh on a sheet of silicone-backed paper. Nip the tiles into shape and glue them flat side up to the mesh. (If you wish, you can lay the tiles out on the brown paper before transferring them one by one to the mesh.) Start with the border, then mosaic the main features, and finish with the background.

4 Spread adhesive on the wall using the notched trowel, and glue the patterned tiles between the plain ones. Press the tiles firmly into the adhesive to ensure a good bond. Complete the wall, then leave until the adhesive has dried.

5 Using a squeegee, spread grout over the mosaic tiles and work it into the gaps between the plain tiles. Clean with a squeezed-out sponge. When dry, polish with a dry lint-free cloth.

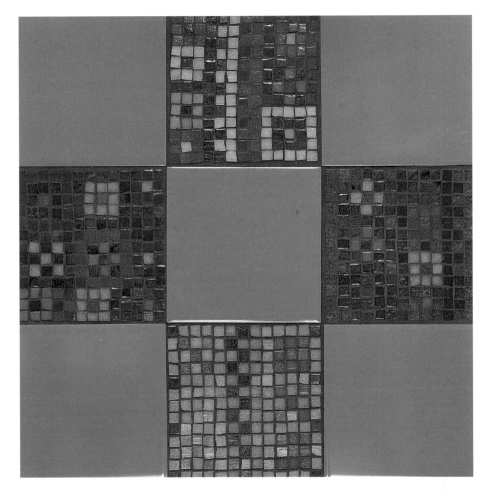

These decorative tiles were made with quartered vitreous glass tesserae, and the intensity of the colours was enhanced by using a dark grey grout. The patterns were inspired by the kinds of designs often found in woven or stitched fabrics. In the rich colours chosen here, the overall effect is reminiscent of Turkish or Afghan carpets. One of the advantages of making things by hand is that each piece can be different. This avoids the tedium of repetition and allows you to explore variations on a single theme.

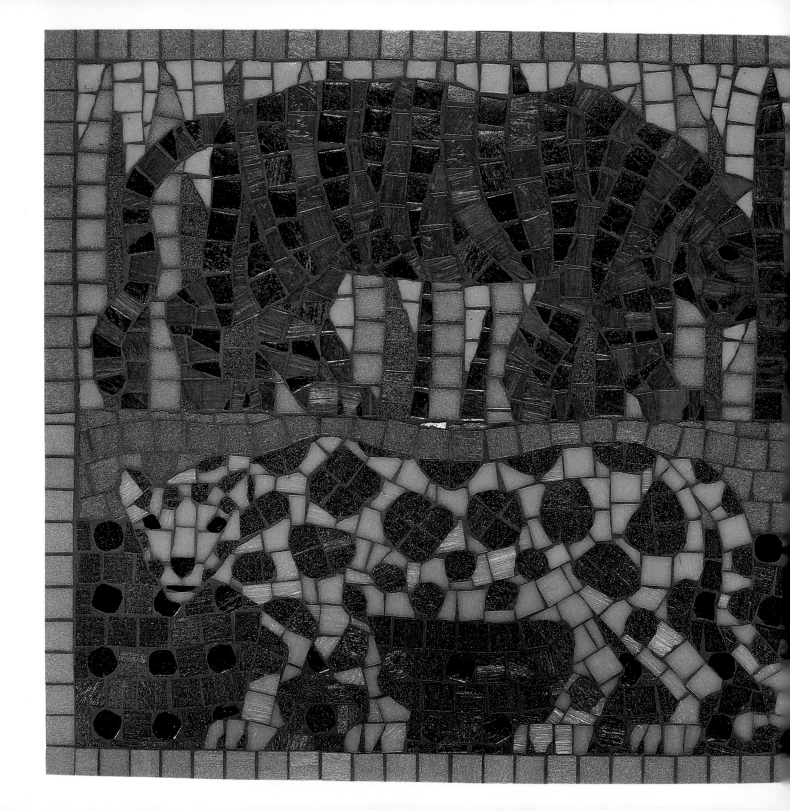

Animal Frieze

Animals' body patterns were the inspiration for these friezes, which are perfect for a child's bedroom wall. In each panel, the marking on the animal has been carried on into the background. For example, the leopard has a background based on spots, while the zebra on page 43 stands against a sky marked with stripes. This is a reflection of the phenomenon of camouflage, in which nature uses markings to blend in with the patterns of light, shade, and shape found in the surrounding environment. It is a fruitful area to explore in mosaic, but there can be a fine line between interest and invisibility, as is shown on page 83.

This project uses quite a wide range of colours. The animals all relate to each other because there is high contrast in their patterns, either bright and dark or light and dark. The background colours are closer in tone and hue.

*Nature is a rich source of
mosaic ideas, but try to keep your
designs simple and bold.*

MATERIALS YOU WILL NEED

Scissors
Brown paper
Charcoal pencil
Vitreous glass tiles
Nippers
Paintbrush
*Water-soluble PVA glue
diluted 50/50 with water*
Black grout
Rubber gloves
Sponge
Cement-based adhesive
Latex additive
Notched trowel
12 mm (¹/₂ in) MDF

To make a wall frieze, use the indirect method demonstrated in the Horse Tile project on pages 30–33. Sketch out your design in charcoal, bearing in mind that the finished picce will be reversed. If you want to do a colour drawing first, you will then have to transfer it to the backing paper as described on page 34.

Lay three sides of the border first, leaving one side open in order to sweep out broken pieces. Work on one section at a time, starting with the main figures then filling in the background.

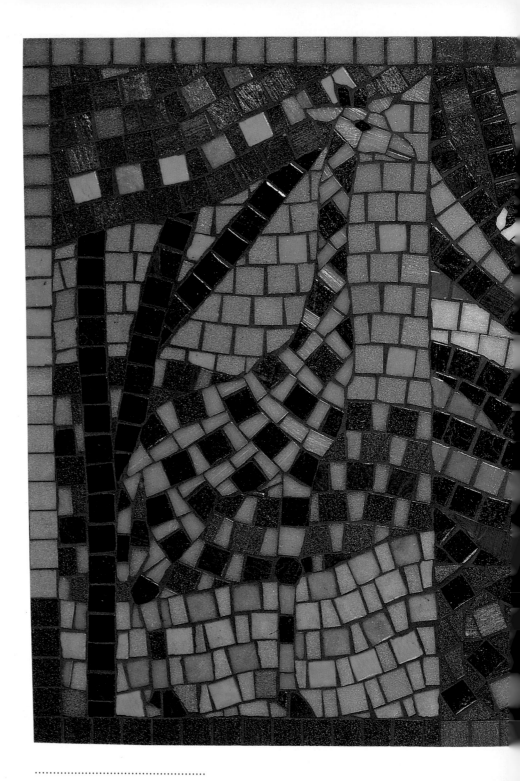

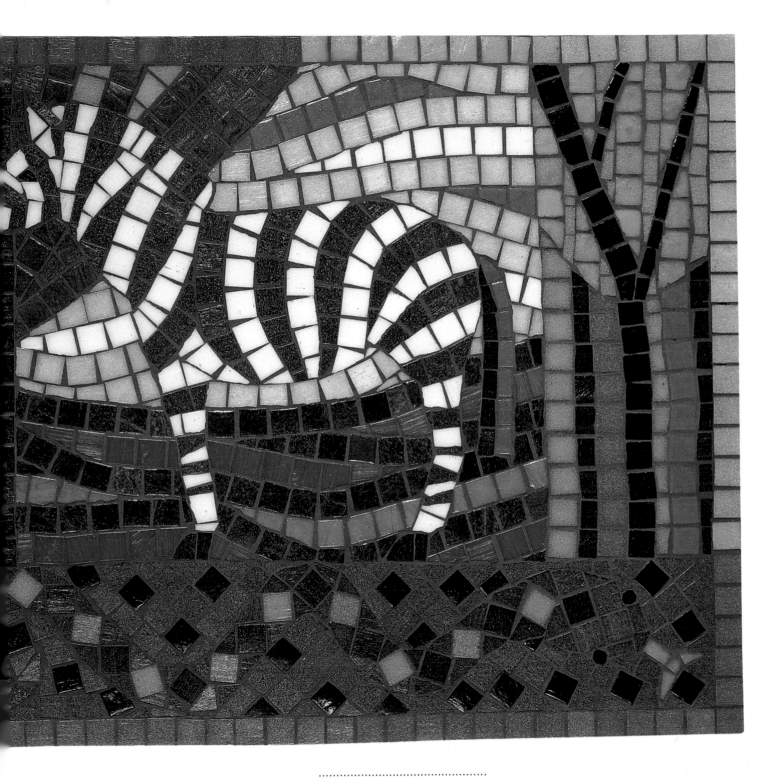

BLACK AND WHITE AND TEXTURE

When working in black and white, you can experiment with effects that would go unnoticed in colour. Making things simple means a greater concentration on the essentials of mosaic: the placing of grout lines, the angles at which the tiles are cut, and the effects created by varying the size of tiles. In this section we hope to show you how sophisticated these effects can be.

A surprising number of effects can be created by the method chosen to lay the mosaic, and the simplicity afforded by black and white tiles allows you to concentrate on these laying techniques.

Grey Bowls demonstrates a particular laying method in which the mosaic runs in a single line across the whole work. The idea was to create a sense of calm, and the simplicity of approach makes it possible to appreciate small variations in the line. The slight waviness would be lost if there were more colours, if the design was busier or if the size of the tiles varied.

Of course, you can make a design busy and use the resulting visual restlessness to good aesthetic effect. Varying and contrasting cutting methods can be a way of making a design easier to 'read', distinguishing between abutting areas of the same colour that would otherwise run into each other. This crocodile mosaic (right), the entrance to London's Groucho Club, is a good example. It is executed in black and white, with a minute amount of green and gold used in the eyes. The usual way to distinguish the subject from the background would be to use black lines to create an outline but here the

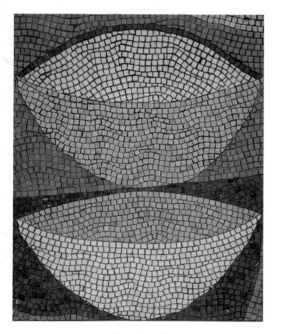

Grey Bowls

Groucho Club Crocodile

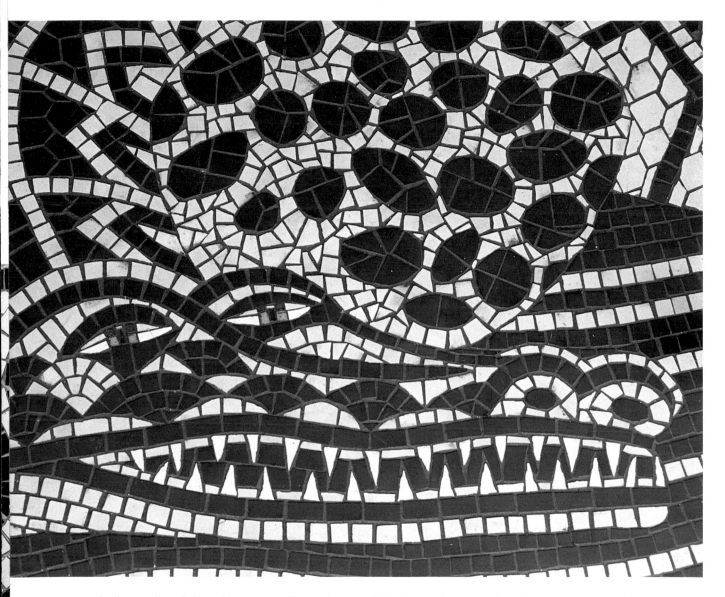

background and the subject are made up of areas of black and white. Instead, the piece is made readable by using contrasting styles of cutting: small quarters for the background and a variety of larger shapes for the crocodile itself. The scaly belly uses a honeycomb cut, the length of the back long, rectangular cuts, the legs crazy-laid fractured tiles, and – most obviously – long pointed triangular pieces for the teeth.

..

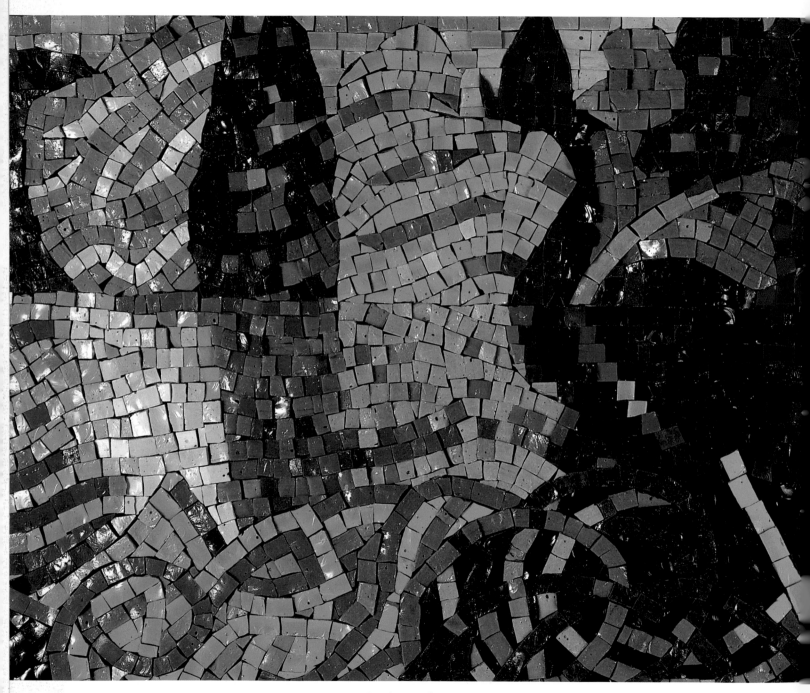

Smalti Landscape

This piece, *Smalti Landscape*, is made entirely with smalti. Smalti is a pitted, fractured enamelled glass that loses a great deal of its intensity if it is grouted, as the small holes in the glass fill up and mute the overall appearance. The fractured curved surfaces are extremely reflective of light, and the intensity of colour can make the material quite difficult to use. As you will see in the Garden Panel, even a small amount of smalti can introduce a strong element of colour to a piece.

Obviously mosaic that isn't flat is not suitable for dusty places, for example, or sites where it would be underfoot. The best locations are probably places that are dust-free, well lit, and can be viewed from a distance. The Garden Panel and the House Number (pages 60 and 64) are both wall-mounted pieces.

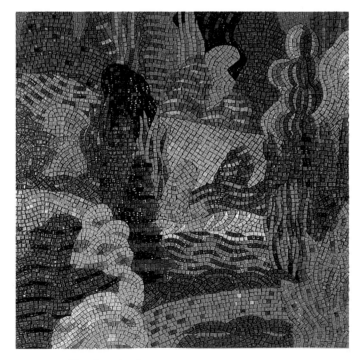

Blue Landscape

Paving Slab

The slab made for this project uses a traditional fan arrangement of tiles. Once you have mastered the technique, try creating other simple patterns such as the ones shown opposite. One reason the different patterns harmonise so well together is the use of a single material: black and white marble.

The paving slabs are designed to make up a garden path or a central feature. Although quite time-consuming to produce, they are especially useful if you are new to mosaic as they demonstrate a broad range of techniques.

MATERIALS YOU WILL NEED

Scissors
Brown paper
Water-soluble PVA glue
diluted 50/50 with water
Marble cubes (approx. 2 kg/4 lb
cubes at 13 mm/¹/₂ in thick)
Pair of compasses
Pencil
Nippers
Wooden base board and
lengths of timber
Screws and screw driver
Petroleum jelly
Lint-free cloth
Rubber gloves
Cement
Squeegee
Sponge
Trowel
Sand
Wire cutters
Expanded metal lath (EML)or wire
mesh. (Available from
hardware stores.)
Flat-bed squeegee
Polythene bag

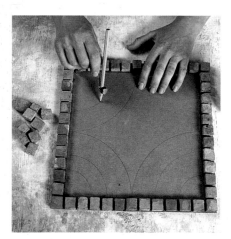

1 Cut out a square of brown paper. Start by gluing marble blocks to the outer edge of the paper as a border. Leave a consistent gap between the pieces. Using a pair of compasses, draw semi-circles at each corner.

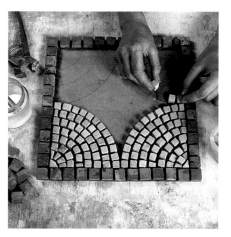

2 Glue smaller marble tiles in fan shapes starting at the top of each fan. Use the lines you have drawn to guide you. Cut tiles to the correct shape as you need them.

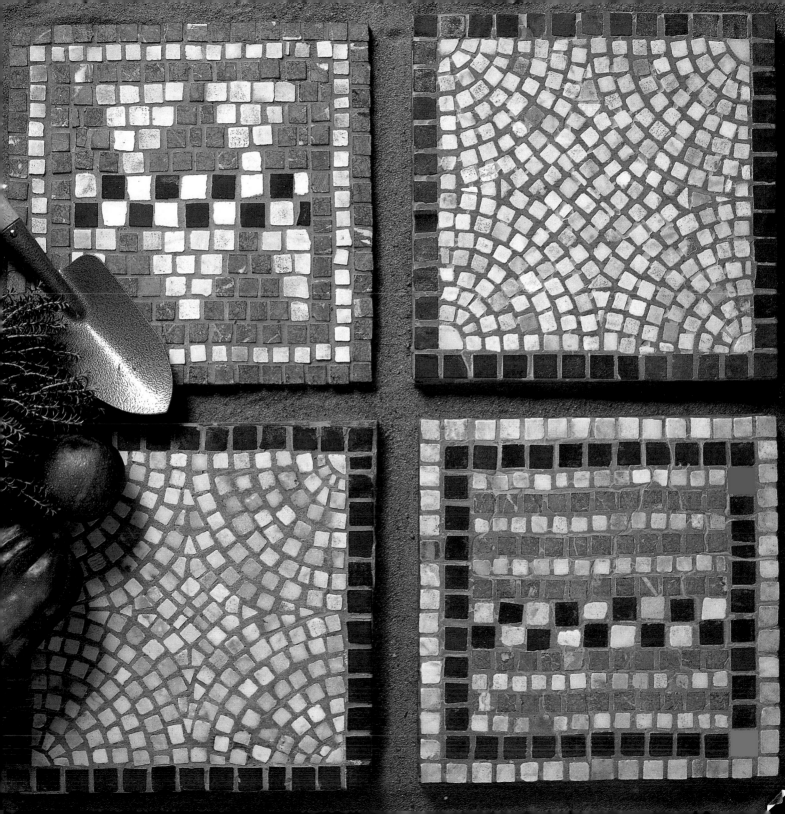

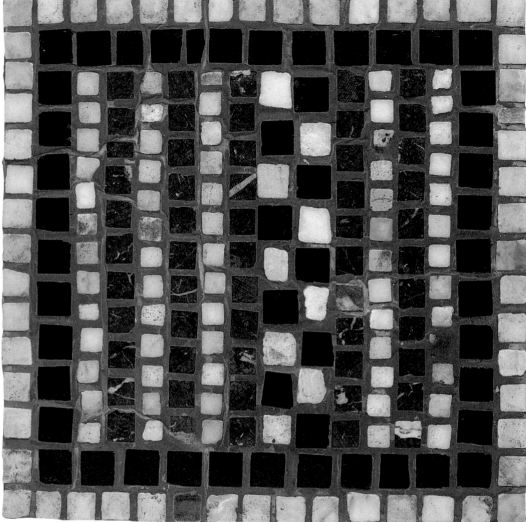

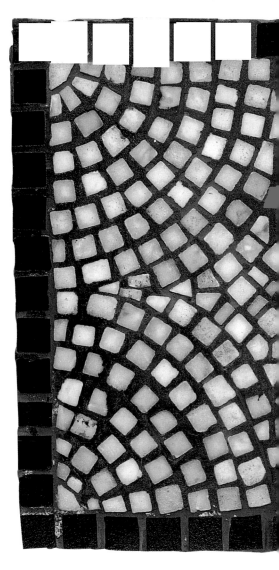

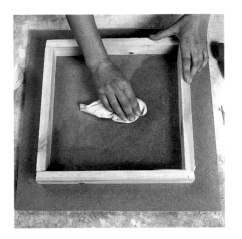

3 Make a frame by screwing together four lengths of timber, then screwing these to a base board. To find the length of each section, allow the length of one side of the paper square plus the width of a single timber section, plus a few millimetres so the fit isn't so tight that the paper folds when you place it in the frame. Grease the inside of the frame with petroleum jelly.

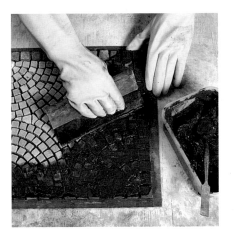

4 Place the finished mosaic on a board to protect the work surface, and grout with a cement slurry. This is a mixture of cement and water, made to a thick creamy consistency. By using a squeegee, you can ensure that the mixture penetrates all the joints.

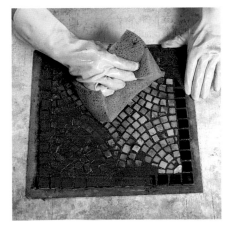

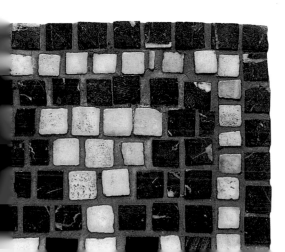

5 Wipe the surplus slurry from the surface of the mosaic with a damp, thoroughly squeezed out, sponge. If the sponge is wringing wet it will make the paper soggy and cause the mosaic to fall to pieces.

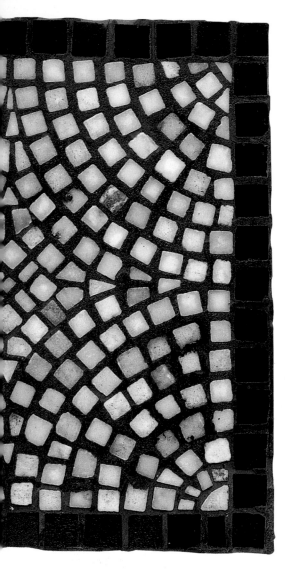

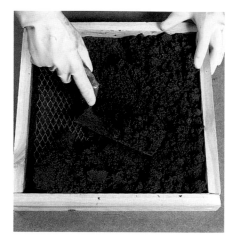

6 Lift the mosaic off the board and lay it, paper side down, in the mould. Try to judge how much sand and cement would fill the mould, and mix it in a ratio of three parts sand to one part cement. Add just enough water to make this workable (not wet and sloppy). Spread a layer over the surface of the mosaic, to about half way up the mould. Cut a square of metal lath as a strengthener for the slab. Fill the mould to the top with the remaining sand and cement, thoroughly covering the lath.

7 You are now working on what will become the back of the paving slab. Tamp down the surface so that it is smooth. Cover in polythene and leave to dry for a couple of days.

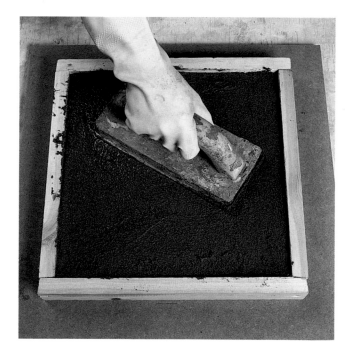

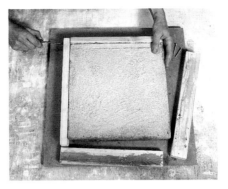

8 Even after two days the mosaic will not be completely set, so handle it gently while you tackle these final tasks. Turn the mould over and remove the screws holding the timber frame to the base board. Turn the mould the right way up and dismantle the frame by removing the screws. Slide the slab out.

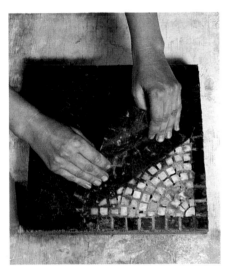

9 Turn the slab the right way up and soak the paper with water. Carefully peel away the paper, working from the corners to the middle of the slab. Clean the surface with water, regrout, and buff with a dry cloth. Cover with polythene and set aside for a couple of weeks for the slab to cure. Bed the slab into a combination of dry sand and cement. When you feel it is positioned correctly, wet the sand and cement thoroughly.

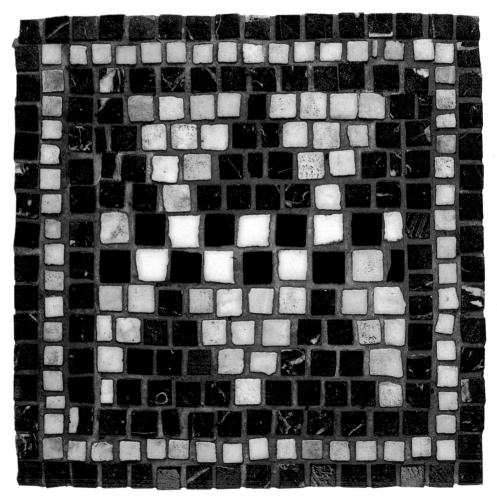

Table Top

This ceramic table demonstrates many of the features discussed on pages 44–46, in particular the variety of effect produced by different cutting methods. This is a large piece, but you can use the same technique to create a smaller table.

Virtually every fish is given a different cutting and pattern treatment. You can copy the kinds of treatment we have used or make up your own. The background is made readable against the fish by the continuous quarter-cut wavy line that runs the length of the table from black to white, and back to black again.

Don't be afraid to try effects that may not be easy to read when the piece is ungrouted: for example, black and white fish on a white background. Providing you use a contrasting cutting technique, when the piece is grouted your fish will become clearly legible. Only by experimenting will you discover what works and what doesn't.

MATERIALS YOU WILL NEED

Scissors
Brown paper
Charcoal pencil
Black and white ceramic tiles
Nippers
Pencil
Water-soluble PVA
diluted 50/50 with water
Grey grout
Rubber gloves
Squeegee
12 mm (¹/₂ in) Marine ply
Exterior cement-based adhesive
suitable for use on wood
Latex additive
Thin timber for the frame
Panel pins
Paint
Lint-free cloth

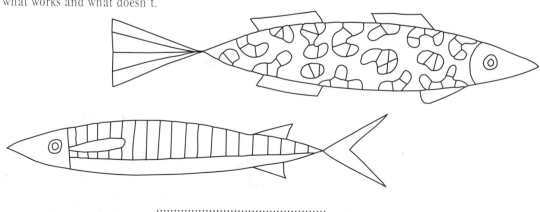

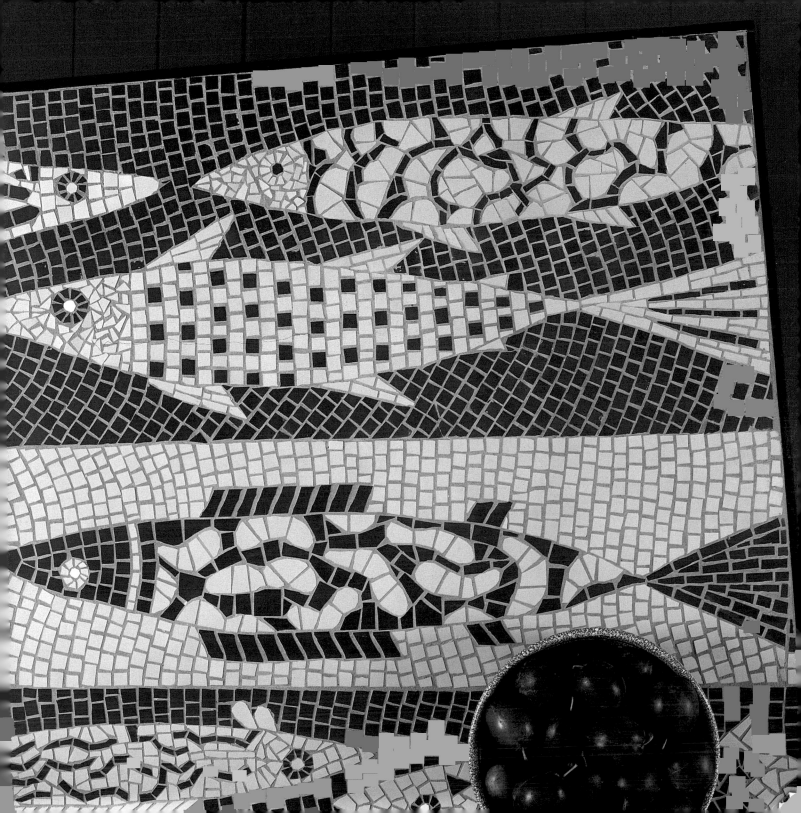

The Table Top is made using the indirect method. When completed, pre-grout and fix to the base board in sections using an even layer of cement-based adhesive combined with a latex additive. To check the alignment of the tiles, peel off the paper and adjust any odd spacing section by section. When the whole piece is laid, wipe over with a damp (not wet) sponge and leave to dry. When the mosaic has properly adhered, regrout, wipe over with a squeezed-out sponge, and buff up with a dry, lint-free cloth. Frame and mount on a table base.

1 Cut out a piece of paper the size of the finished table, and draw your design on it in charcoal. Remember that you need a balance across the whole piece between clarity and subtlety. Cut the paper down into manageable sections. Begin by laying the most significant features of the design, in this case the fish's spots.

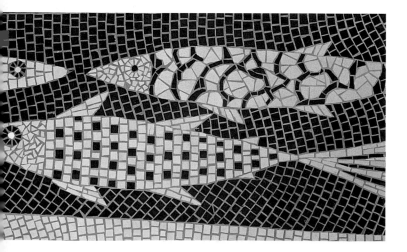

2 A fairly ambitious pattern like this requires some complex shapes. These are made much easier to produce if you cut a shape you think is approximately right, then fine-tune it by nibbling the edges with nippers. Luckily, ceramic is easy to draw on with a pencil. Placing the tile where you want it to go and marking the line helps when the shape that you need to cut is a difficult one to remember.

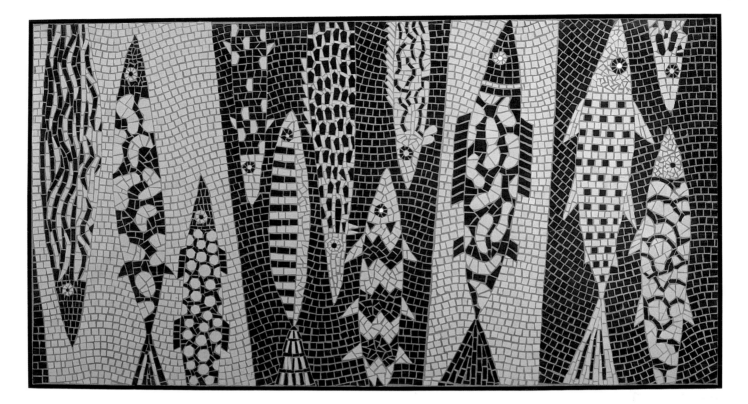

*Our table is about 2 × 1 m (6 × 3 ft) wide.
A large piece like this, done in reverse on paper, cannot be
turned over easily, so you must plan how to divide it into
sections. Here, the changes in colour represent the lines
along which the paper has been cut.*

3 Cut along the pencil line that you have drawn. The off-cuts
you produce can be used elsewhere in the design. Don't be a
slave to your original charcoal lines; it's the way the tiles fit that
matters. As the spots are crazy-laid angled cuts, the background
will be given the same treatment. This helps make a busy design
more harmonious.

Garden Panel

The tree depicted in this panel is divided into four seasons, with different blends of materials used to create the mood appropriate to each time of year. The winter sky is made from marble pebbles, the spring sky features gold and smalti tiles. The piece depends for its effect on contrasts, not just of colours, but of materials: riven and saw-cut marble, gold-leaf glass, marble pebbles and intensely coloured smalti. The mosaic is intended to be placed in an outdoor setting, where its rugged texture and earthy colours can best be appreciated.

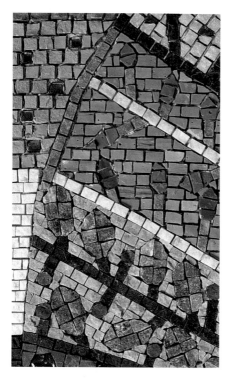

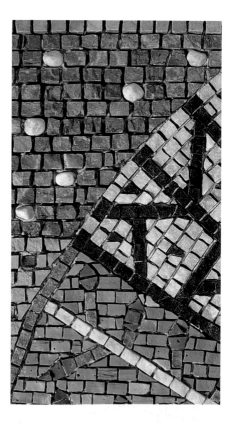

MATERIALS YOU WILL NEED

*12 mm (¹/₂ in) Marine ply
Screws and screw-driver
Length of batten for
wall mounts
Thin timber for the frame
Panel pins
Paint
Charcoal pencil
Saw-cut marble cubes
Polished marble cubes
Marble pebbles
Gold tiles
White, slow-setting exterior
cement-based adhesive
Latex additive
Palette knife or old knife
Nippers
Smalti tiles
Marble rods*

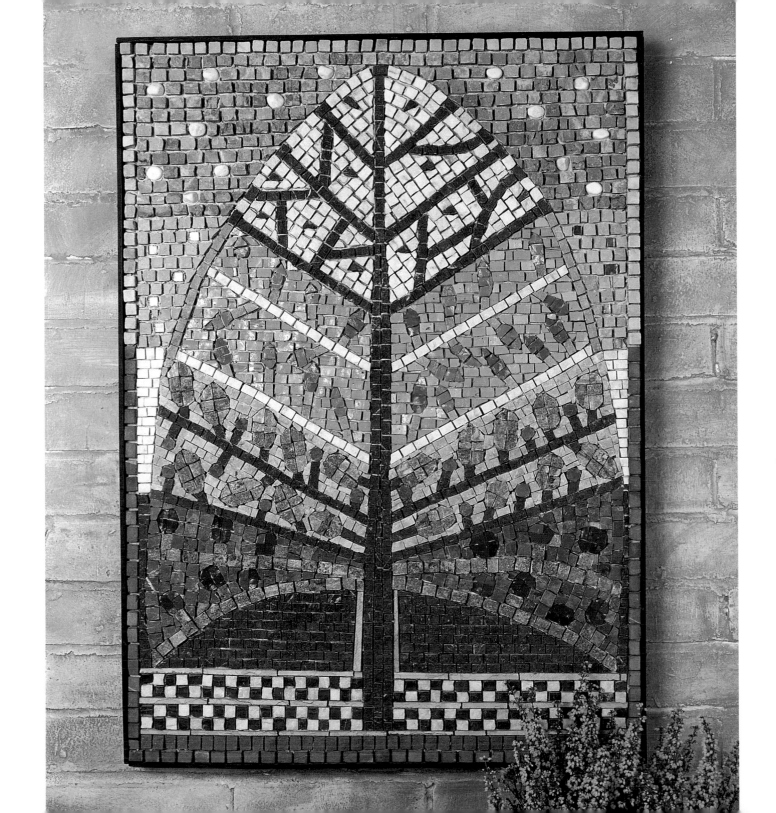

1 Prepare a board so that the completed mosaic can be hung on a wall. First screw a horizontal batten near the top of the board, and a second one near the bottom, securing them with screws drilled through from the front of the board. The screws should be countersunk so that the tiles will lie flat over them. Next, make the frame with four pieces of wood, which should be the same depth as the thickest tile, secured with panel pins. Paint the frame and let it dry.

Next, draw the design directly onto the board with charcoal, which allows you to make changes. When planning colours, think about the way smalti and the natural materials will complement each other. Bear in mind that the colours of the pieces look more intense when they have been cut. To make sure your colour choices work, you might like to lay out a small area before you begin cutting and fixing the tiles.

2 Choose an adhesive that is suitable for exterior use and that will bond to wood. It should also be slow setting, to give you sufficient working time. Begin by fixing the whole saw-cut cubes around the border. Push the cubes into a fairly thick bed of adhesive applied with a palette knife or old knife. If you apply too much adhesive it will squeeze up between the tiles and foul the surface of the marble. Apply to a smallish area at a time, otherwise a skin may form on the adhesive and prevent good bonding. Clean any surplus off the board right away or it will 'go off', leaving a lumpy surface. After completing the border, start on the branches. (It is a good general rule to begin with the main feature of a design.) Cut the marble cubes in half with the fractured (riven) face laid towards you, pressing the flat face into the adhesive.

Try to leave an even gap between the tiles. Make sure the smalti tiles are in proper contact with the adhesive. This is more difficult than in the case of marble because of their uneven shape. You might have to lay them into a slightly thicker bed of adhesive. (If any adhesive gets onto the face of the smalti, remove it with a pin.) Complete one branch then do the leaves. When the tree is complete, fill in the sky.

At the base of the tree, we have used marble rods to contrast with whole black and white marble cubes. With a broadly symmetrical mosaic like this one, complete one half first before starting the other side.

House Number

n this project we make a house number using white marble cubes and green marble pebbles: the contrast in material is intended to make the sign easy to read from a distance. The finished mosaic can be fixed on a wall using the same exterior adhesive that you use to fix the cubes and pebbles to the tile. When positioning the number, use a spirit level to check the alignment.

MATERIALS YOU WILL NEED

Black marker pen
Exterior quality ceramic tile
Brown paper
Nippers
White marble cubes
Grey exterior slow-setting
cement-based adhesive
Palette knife or old knife
Green marble pebbles

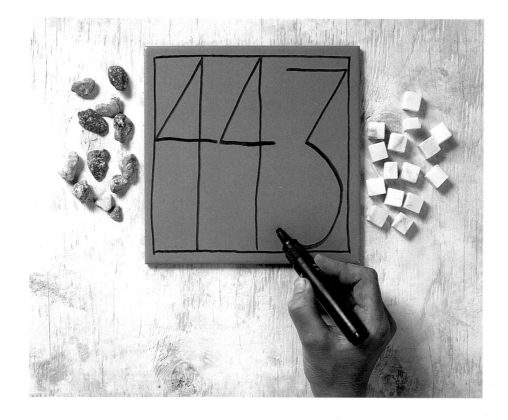

1 Draw a border and the number you plan to mosaic on the shiny, glazed surface of the tile. If you don't feel confident enough to remember the design as it gets covered in adhesive, you might find it helpful to copy it onto an identically sized square of brown paper. You can then refer to this as the tile gets covered up.

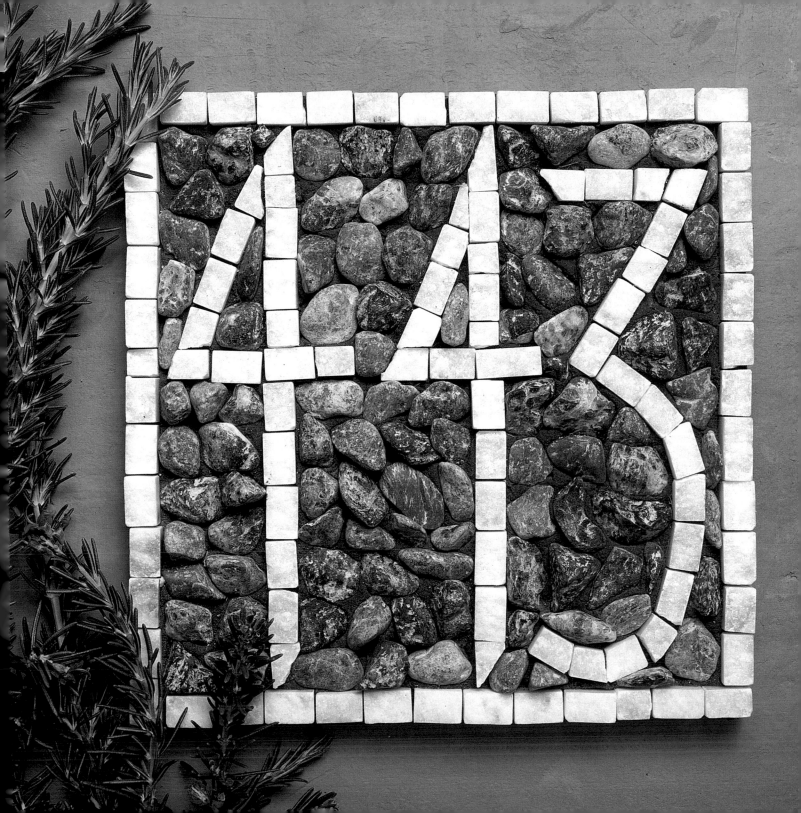

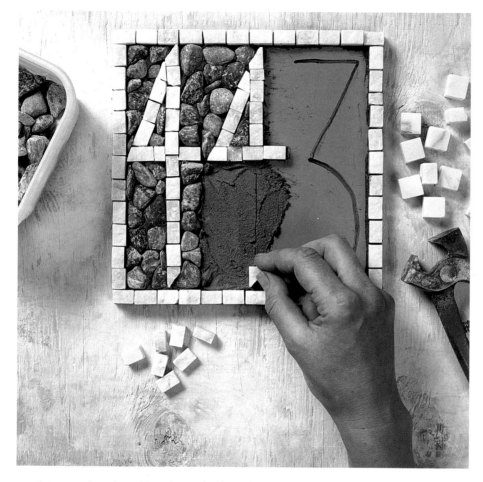

2 Cut a number of marble cubes in half. Apply adhesive to the border and press the tiles into it with the fractured (riven) face outwards. Do not apply so much adhesive that it oozes up between the joints. Cut more marble cubes as required. Once the border is complete, begin the numbers. Fill in the background with pebbles. As these are uneven and rounded, use plenty of adhesive to secure them.

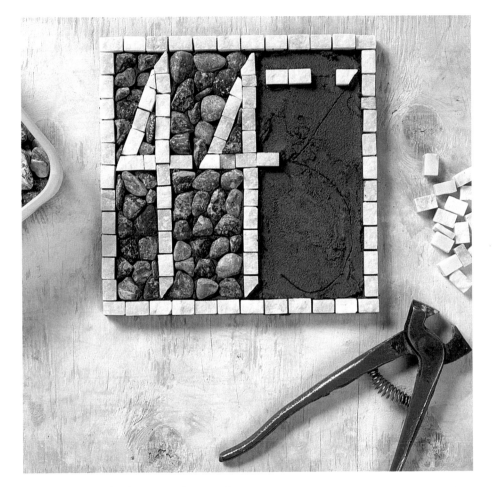

3 As you cover the drawn number, mark the outline in the adhesive with the tip of your palette knife. Nip the blocks to fit the design where necessary, and position them on the centre of the line you have made. As the adhesive is grey and similar in tone to the pebbles it doesn't matter if some shows, but do try to keep the pebbles clean.

3-D OBJECTS

Mosaic is a very versatile medium, and can be stuck to virtually anything. During the sixties it was fashionable to cover entire office buildings with vitreous glass. Now that mosaic is again popular it is being used to transform everything from birdbaths to swimming pools.

The key to success is to use the right adhesive for the background that you are working on and the location of the finished piece. You will find plenty of practical advice on this subject on pages 16 to 19 of the Introduction.

When deciding on a mosaic project do bear in mind that some of the properties of mosaic can cause problems. For example, when marble cubes are fixed and grouted they are very heavy. A large tray decorated with marble mosaic could well be too heavy to lift. Another consideration is that mosaic is not very pleasant to touch and is unsuitable for things that should be smooth and tactile, such as handrails and door handles. Mosaic can also be vulnerable to knocks and general handling, and any object that has exposed mosaic edges should be

treated with great care. (See page 85.) An ideal object to decorate with mosaic is a small wooden tray with raised edges (see left) that provide protection for the edges of the mosaic tiles. Curved surfaces do not present a problem, because the small mosaic pieces will follow the contours of the piece. However, the design will be distorted by the curving surface, so it is best to keep it simple.

One of the properties of vitreous glass that can be exploited in smaller projects is the translucency of some of the colours. To make a light-box, such as the one shown opposite, mosaic is glued to clear glass with silicone then mounted in a wooden box containing a light bulb. It is possible to use different layers of translucent glass including stained glass so that the colours overlap and create complex three-dimensional patterns. You can also use daylight as the light source and make coloured glass panels to hang in the window.

Candle Holder

These stunning candle holders are made using coloured glass, which is widely obtainable from stained glass suppliers, some glass merchants, and arts and crafts shops. You can use the same technique on any clear glass object, bearing in mind that it should be a simple shape to avoid difficult cutting of the glass pieces. When working on a curved surface, your design should relate to the direction of the curve. Use small pieces of glass around the radius and long pieces down the vertical faces. Apply plenty of silicone adhesive in Step 3, as the grout will seep under the glass pieces and spoil the finished effect if you don't.

When complete, drop a night-light in the bottom of the tumbler and light with a long taper. You can also use regular candles, but bear in mind that you will eventually have to dig out the old wax from the base of the glass.

MATERIALS YOU WILL NEED

Scissors
Brown paper
Tumbler
Pen
Coloured glass
Glass cutter
Ruler
Tile-cutter
Silicone sealant
Old knife
Tissue
Black grout
Rubber gloves
Sponge

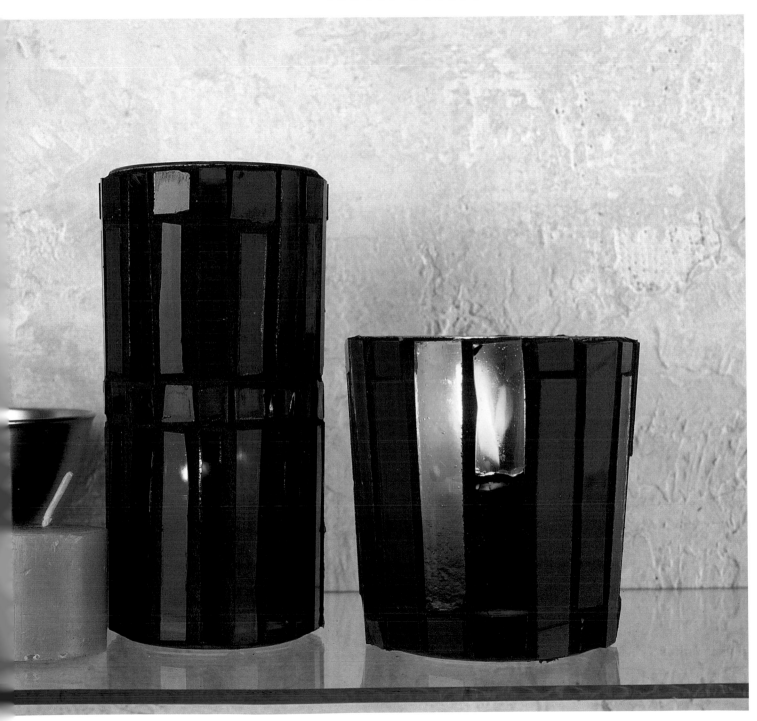

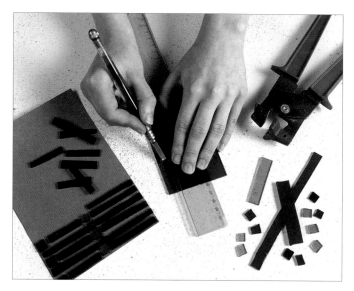

1 Cut a piece of paper slightly smaller than the size of the tumbler you plan to decorate.

2 Score the pieces of glass using a glass cutter and a ruler. Snap the glass into lengths and arrange them on the paper pattern.

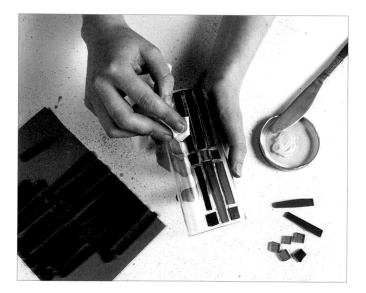

3 Apply a generous layer of silicone sealant to the back of the glass pieces. Position them on the tumbler, and press down using a tissue. Leave to dry for about half an hour.

4 Apply grout by hand, working it right up to the rim of the tumbler. Wipe off the excess with a squeezed-out sponge. Leave to dry for at least a half hour.

Brooch

Cutting tiles into tiny pieces requires patience. Nip a 20 mm (¾ in) tile into quarters, then quarter the quarters, and finally quarter them again. As they get smaller, some pieces will shatter, but there is no need for them all to be perfectly square or exactly the same size. A bit of variety will add liveliness to the brooch

For this project we used metallic tiles, but you can use vitreous glass tiles. The bevelled edges will be unsuitable, but you can make tiny cubes from the centre of the tile. You can also use smalti and even marble.

When the piece is finished, glue a brooch pin or pendant hanger to the back of the box using an epoxy adhesive.

MATERIALS YOU WILL NEED

*Aluminium
Metal ruler
Stanley knife
Pencil
Scissors
Pliers
Metal file
Brown paper
Nippers
Metallic tiles
Water-soluble PVA
diluted 50/50 with water
Darning needle
Old knife
Sponge*

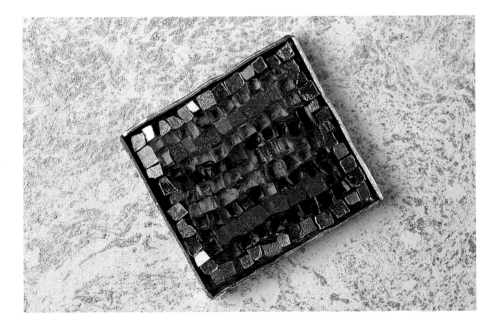

Cutting the tiny pieces to make this mosaic demands patience, but the resulting brooch is certainly worth the effort.

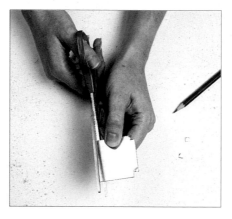

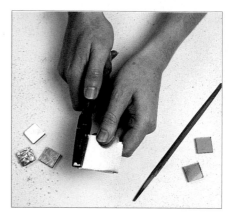

1 Score a box shape in the aluminium with a Stanley knife and mark out the corners in pencil. (The edges of the box must be the same depth as the tiles.) Bend along the scored line to snap it.

2 Following the pencil marks, cut out the corners with a pair of scissors.

3 Using pliers, carefully bend up the sides of the box. The sides might bend unevenly at first, but can gradually be straightened out. File down any sharp edges that might catch on your clothes.

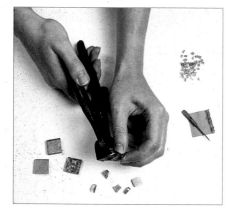

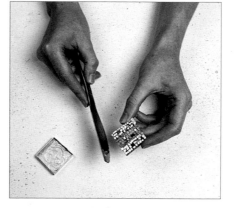

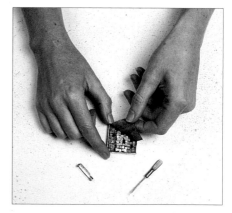

4 Cut a piece of brown paper the same size as the inside of the box. Nip the tiles into tiny pieces and glue them to the paper pattern, right side down. You might find it helpful to have a small pointed tool – a darning needle is ideal – to help position the pieces.

5 Spread a layer of silicone sealant inside the box with an old knife, making sure that it goes right into the corners. Spread a thin layer over the back of the mosaic to compensate for any unevenness in the height of the pieces. Place the mosaic in the box and press down gently.

6 Using a squeezed-out sponge, damp the backing paper. Keep it damp for 15 minutes. Carefully peel off the paper, using the darning needle to poke back any tiles that come loose. If any of the sealant has come up between the joints, scrape it out with the needle.

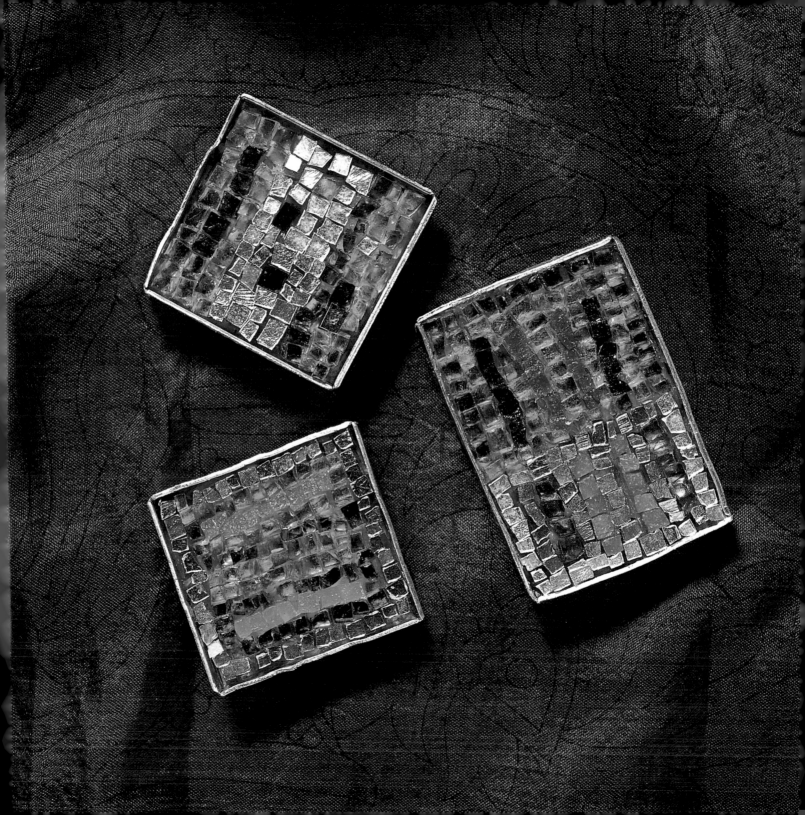

Terracotta Planter

This simple mosaic planter was designed and made by interior designer Linda Barker. Inexpensive terracotta planters like this one are easy to transform, and make wonderful containers for indoor and outdoor plants. Garden centres and home-improvement stores tend to have a good range of pots. Choose a frost-proof planter for outdoor use and make sure that it has smooth, even sides. Once you have placed it where you want it, avoid moving the planter around as handling may disturb the tiles at the rim.

MATERIALS YOU WILL NEED

Terracotta planter
Pencil
Paper
Ruler
Vitreous glass tiles
Ceramic tiles
Nippers
Non-water-soluble PVA
Mixing bowl
Ivory grout
Filler knife
Water
Squeegee
Lint-free cloth
Rubber gloves

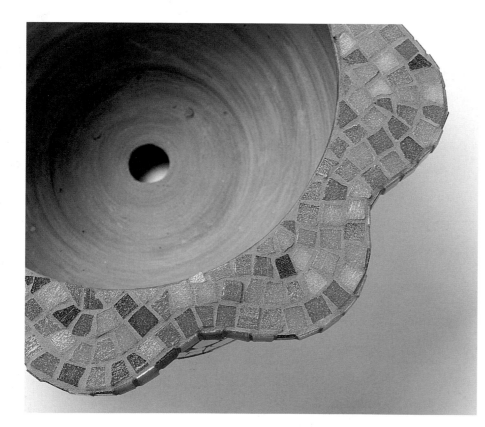

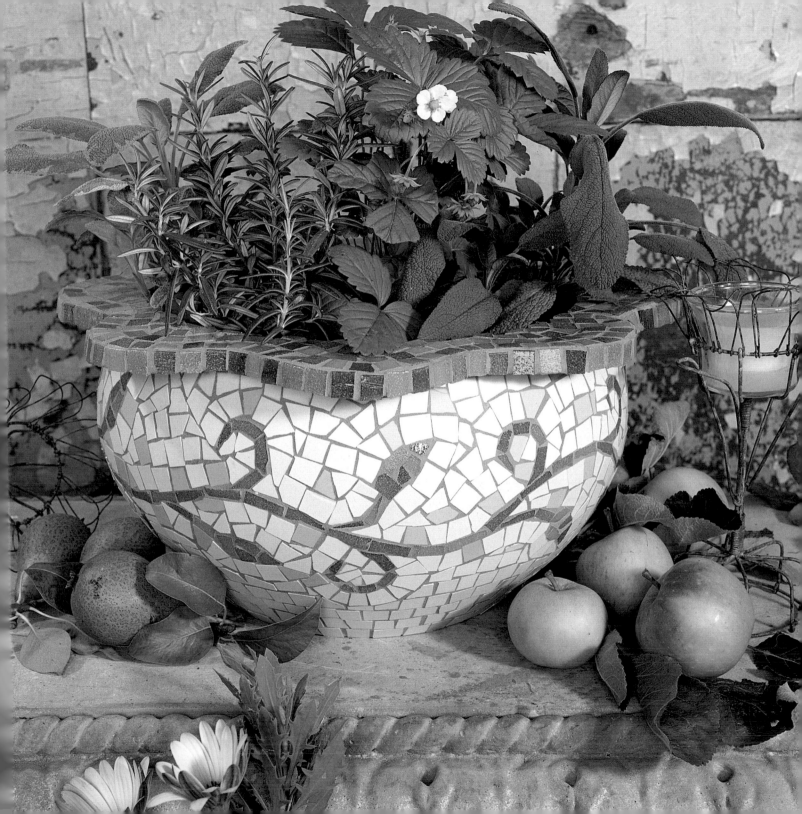

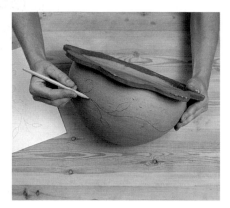

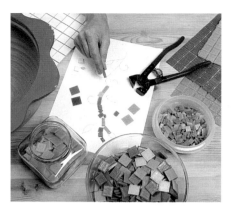

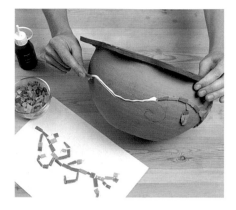

1 On a piece of paper, sketch a simple outline to use as a guide for your mosaic foliage. Use a ruler to plot a line around the planter and use this as the centre line for the foliage border. Draw the central stem on the pot, then add the tendrils and leaves.

2 Select and group together the mosaic tesserae. To create an interesting contrast, Linda used ceramic for the background and glass for the foliage and scalloped edge. Snip some tiles and lay these on your sketch to get a feel for how the colours will look together.

3 Spread a thin line of glue along the pencil line and start to apply the tesserae. (The glue will dry to a clear finish.) Work around the planter, varying the colours to create a pleasing effect.

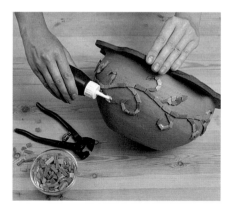

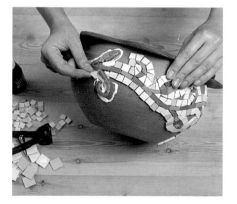

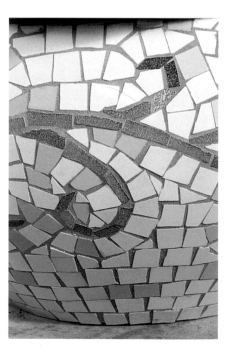

4 Once the stem is in place, add leaves and tendrils. Use the nippers to shape each piece as you go. Remember to vary the colours on these areas, too, as this gives the mosaic character.

5 Once the foliage border is complete, snip the background tiles and begin applying them to the pot. Use the glue as before, working a section at a time. Allow the first row of background tiles to 'snake' around the foliage.

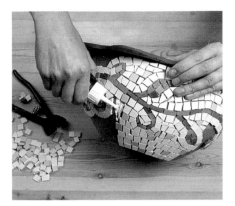

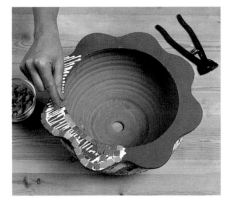

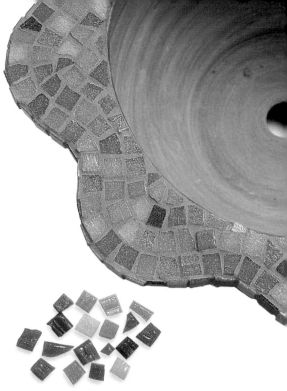

6 Glue two rows of ceramic tiles around the base of the planter, then fill in the rest of the background in a less structured way. Use two slightly different shades of cream or white to add interest. Leave an even gap between the tiles.

7 Fill in the scalloped edge around the planter with the glass tesserae, varying the mix of colours as before. For an effective setting, follow the outside edge and the inside edge before filling in the centre. Don't forget the rim.

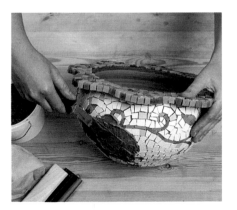

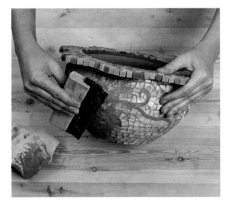

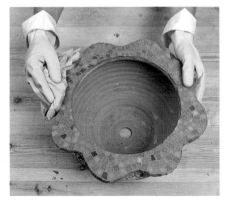

8 Place a small amount of dry, powdered grout in a mixing bowl and make a well in the centre with a filling knife. Gradually pour in cold water and mix to a soft consistency. Put a large dollop of grout on the mosaic surface and spread it over the tiles.

9 Spread the grout evenly with the squeegee. When all of the gaps between the tesserae have been filled, wipe away the excess grout with a soft cloth. Leave the pot to dry.

10 The surface of the planter will be powdery with dried grout. Wear rubber gloves to protect your hands, then wipe the pot clean with a damp cloth.

Smalti Dish

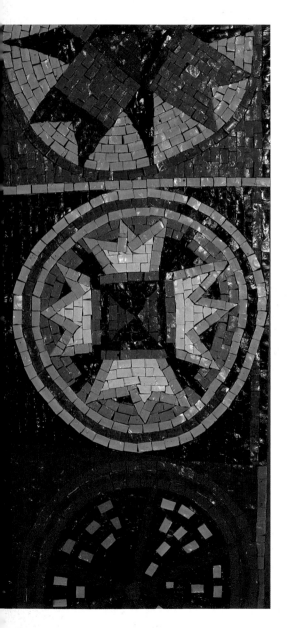

This project demonstrates how to cover a 3-D object in mosaic. The mosaic material is smalti, or enamelled glass, the material used on the great Byzantine wall mosaics. Smalti has an extraordinary intensity of colour and can be very effective in simple patterns. Because it is a material that has an uneven surface, it is best to use a slow-drying cement-based adhesive combined with a latex additive.

MATERIALS YOU WILL NEED

Smalti
Terracotta dish
Pencil
Cement-based adhesive
Latex additive
Paintbrush
Paint

2 Apply a thick layer of adhesive to a small area of the base of the dish. If you cover too large an area, the adhesive will start to skin over. Press the pieces into the adhesive without letting it rise up to the surface in the joints. Cut the pieces as necessary, placing the nippers across the whole width of the tessera, rather than just at the edge as you would with vitreous glass tiles.

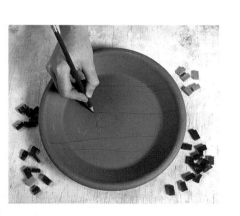

1 Select the colours you are going to use and draw the design on the terracotta dish with a pencil.

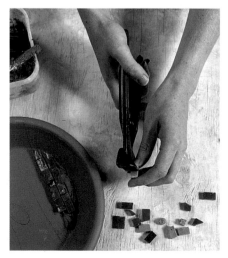

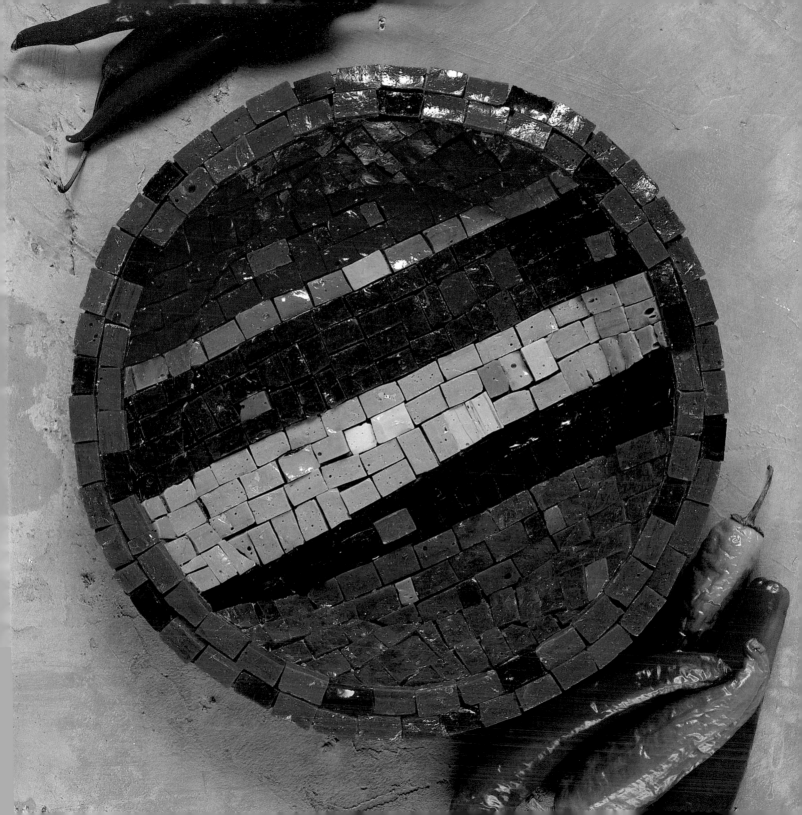

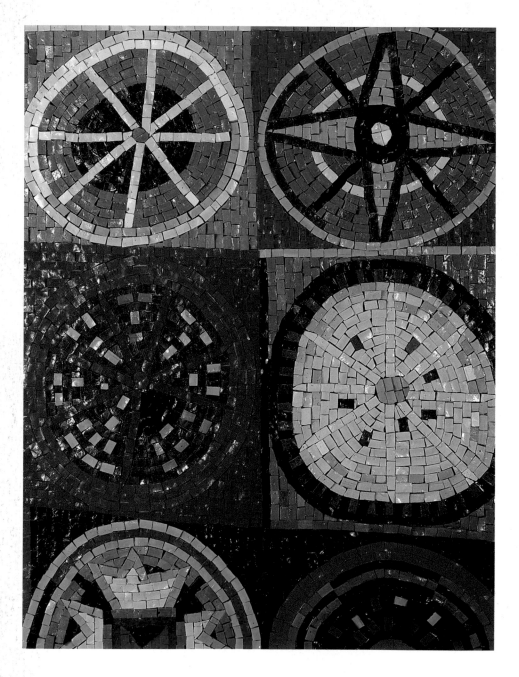

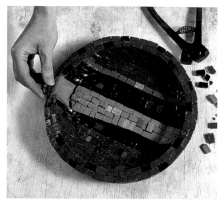

3 When the base is covered with mosaic, apply the adhesive in sections to the sides and rim. It is easiest to do the sides and rim at the same time to ensure a neat junction. Make sure there is plenty of adhesive under the smalti at the rim, as this will be vulnerable to knocks. Leave to dry for two hours.

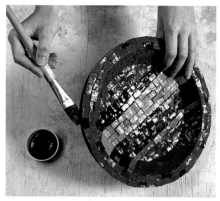

4 When the adhesive is dry, paint the outside of the dish in a suitable colour. Neutral tones work best.

MISTAKES AND HOW TO AVOID THEM

Here is a small selection of pieces that went wrong. By studying our mistakes, we hope that you will be able to avoid making similar ones yourself!

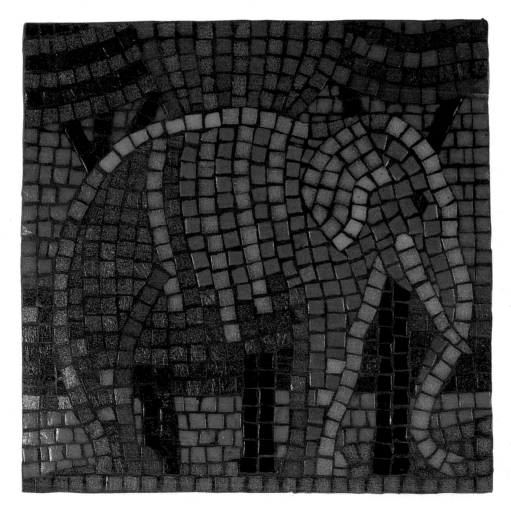

Elephant tile

In this piece, the elephant has started to disappear against the background. There is insufficient contrast either in tone, hue or intensity between the body of the elephant and the sky beyond. The lighter outline is not quite enough to bring the animal forward and it has become, unintentionally, an elephant by moonlight!

Grout changes

The sample shown below right was made to demonstrate the effect different coloured grouts have on the colours of the tiles. It also shows another interesting effect. Sometimes it is desirable to grout different sections of a single piece in different colours, either to break it up, or to use a grout that is sympathetic to a change in the colours of the piece. This sample shows that when you change grout colour the eye reads the demarcation line made by the tiles, making a strong and potentially distracting zig-zag effect. Changes in grout colour should, therefore, always follow the lines along which the mosaic is laid.

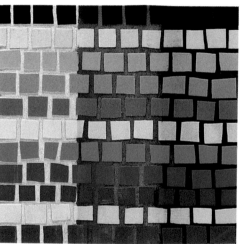

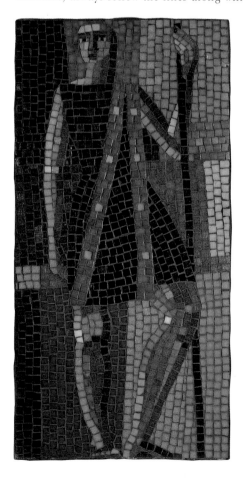

Centurion

This piece (left) shows how there can be a conflict between different approaches in one piece. The figure's body has been treated in a careful way to bring out its three-dimensional form, but the clothes he is supposed to be wearing are treated as completely flat surfaces. Sometimes different approaches can be fruitfully combined and probably the flat background of this piece would have worked had the figure been more coherent.

Insect panel

The mistake made here was the attempt to stick mosaic to the sides of a panel. The bevelled edges of the vitreous glass tiles make this a tempting idea and, although difficult to do, it can look good for a while. However, it is almost impossible to get a solid bond on the edge tiles as they have to overlap the board. They are then subject to movement as the backing board expands and contracts with temperature changes. They are also very vulnerable to the slightest knocks to the sides, and the result is that before long they will fall off, leaving the edges of the main mosaic exposed and vulnerable.

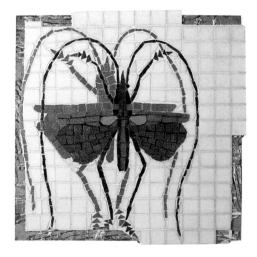

TEMPLATES

The following design templates are taken from step-by-step projects in this book. The designs that were used for mosaics made with the indirect method are shown in reverse. We have also included templates for a further three simple designs: the duck, the swan, and a geometric pattern. Use a photocopier to enlarge or reduce the patterns to fit the area you plan to mosaic.

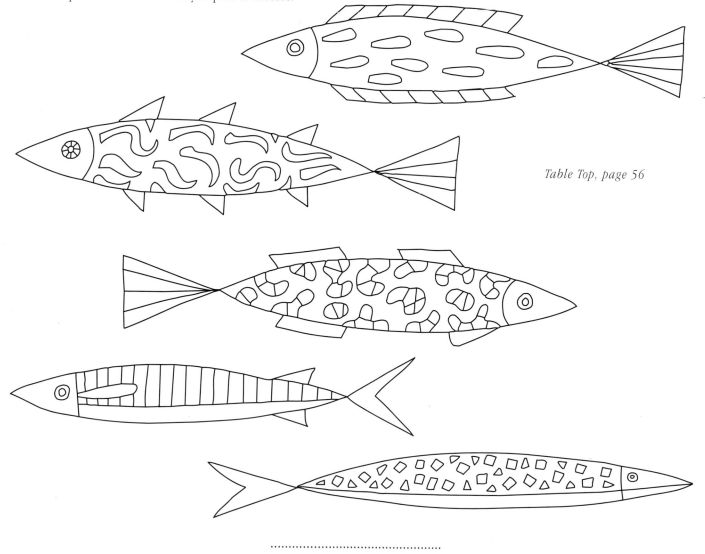

Table Top, page 56

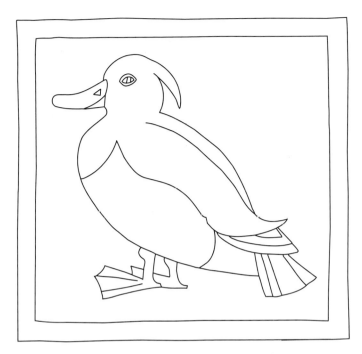

A simple duck design

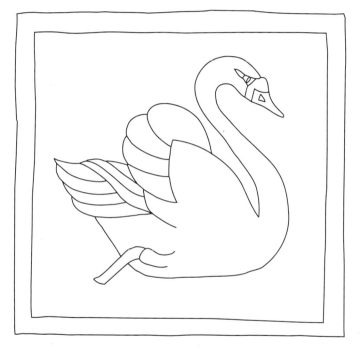

A swan

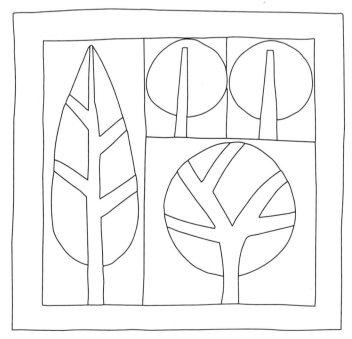

Tiles on Mesh, page 36

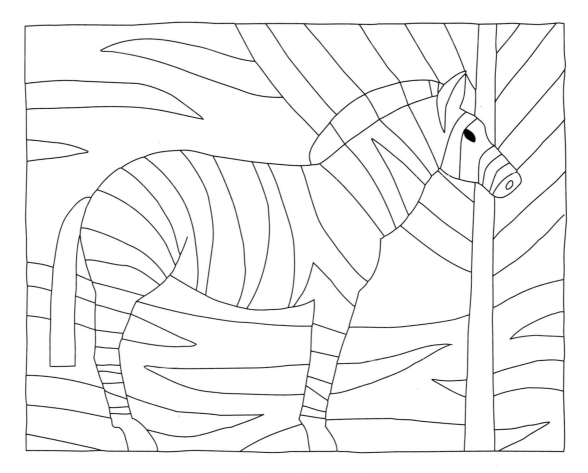

Animal Frieze zebra, page 43

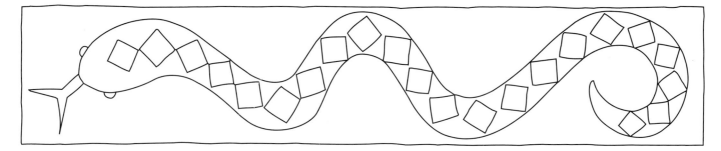

Animal Frieze snake, page 43

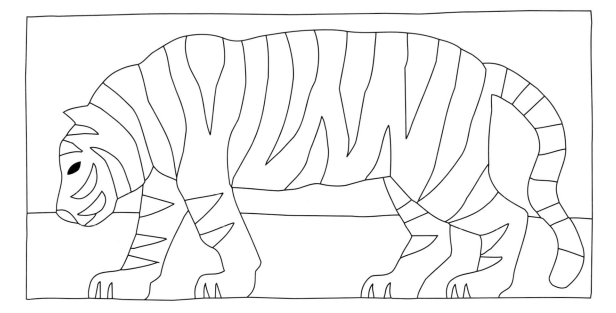

Animal Frieze tiger, page 40

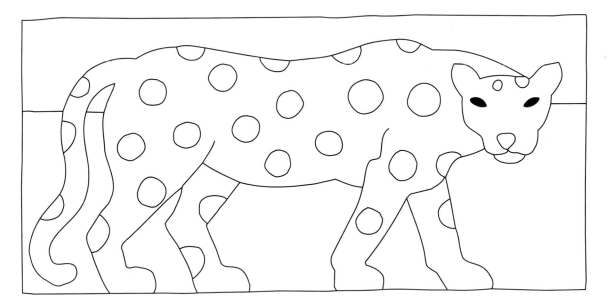

Animal Frieze leopard, page 40

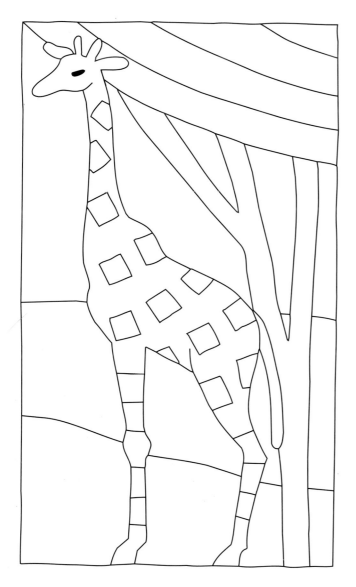

Animal Frieze giraffe, page 42

Horse Tile, page 30

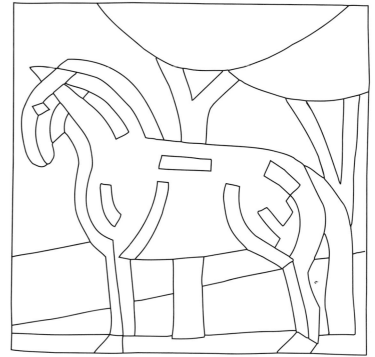

Paving Slab, page 50

Geometric pattern

Suppliers

Timber Merchants

A good local timber merchant will generally cut sections of board for you, although you may be asked to pay for the whole piece. These are generally supplied in 2.80 x 1.20 metre (8 x 4 ft) sheets. Shop around, and do look in timber merchants' skips; materials that they regard as scrap may be the perfect base for a mosaic.

Tile Shops

Many tile shops do not yet supply mosaic, although this may change as demand increases. However, most sell the relevant fixing materials and tools. Always check that the adhesive you buy does what you require, for example, that it is suitable for outdoor use. Some shops may be prepared to give you broken tiles that they would normally throw away.

Hardware Shops

Good for fixings, such as screws, pins and brass wire for hanging your finished pieces. Make sure that the tile cutters they sell are the kind used in this book.

Edgar Udny & Co. Ltd
314 Balham High Road
London SW17 7AA
Tel: 0171 767 8181
Ceramic, glass and smalti. Fixing materials. Mail order service available.

Lead & Light Warehouse
35a Hartland Road
London NW1 8BD
Tel: 0171 485 0997
Stained glass. They will not cut the glass for you, but sell glass-cutting materials. Mail order service available.

Reed Harris
27 Carnwath Road
London SW6 3HR
Tel: 0171 736 7511
Ceramic, glass and marble. Fixing materials. Mail order service available.

Mosaic Workshop
Unit B
443-449 Holloway Road
London N7 6LJ
Tel: 0171 263 2997

Mosaic Workshop Shop
1a Princeton Street
London W1R 4AX
Tel: 0171 404 9249
Glass, smalti, ceramic and marble. Adhesives, tools, boards and all associated paraphernalia are available from the Workshop and the Shop. The Workshop also runs courses. Mail order service available.

Tower Ceramics Ltd
91 Parkway
Camden Town
London NW1 9PP
Tel: 0171 485 7192
Ceramic tiles, marble and terracotta. Adhesives, grout, cleaning materials for marble and terracotta, and all associated tools.

ACKNOWLEDGEMENTS

James, Nichole, Jo, Gideon, Alice and Sallie. Patrick for the flowers.
Hello Lucas. Thanks team.